BARBARA DAVATZ • PORTRAITS 1982, 1988, 1997 • AS TIME GOES BY

Widmung

Dieses Buch ist Pius gewidmet, der die Entstehung der Portraits vom allerersten Augenblick an mit nicht nachlassender Begeisterung begleitet hat, der mit grösster handwerklicher Sorgfalt und göttlicher Geduld mir das schönste Atelier der Welt und meine liebste Dunkelkammer einrichtete.

Dedication

This book is dedicated to Pius. He has accompanied the portraits from the very first moment with unquenchable enthusiasm, and set up the most beautiful studio in the world and my beloved darkroom with supreme craftsmanship and heavenly patience.

BARBARA DAVATZ • PORTRAITS 1982, 1988, 1997

As Time Goes By

EDITION PATRICK FREY

Aus der Dunkelkammer meiner Zukunft

NICOLE MÜLLER

Was ich kannte, waren katholische Jugendgruppen, den Kirchbesuch am Sonntag, die Silva-Bücher mit den schönsten Rosen. Ich kannte das Dorf und die Brombeeren vom alten Zumthor, der auf der Bank an der Sonne sass und mit seinem Stock darüber wachte, dass ihm die Knirpse nicht an die reifen Früchte gingen. Ich kannte den Ausdruck «underem Haag duure frässe». Die Ehe war ein heiliges Sakrament und dass Kunst ein brotloser Beruf war, wurde niemals bedauert. Kunst kam ohnehin selten vor zwischen Miststock und Glockenweihe. Dem Ausruf «Joo, daas isch e Kchünschtler!» war die Gönnerhaftigkeit deutlich anzuhören.

Ich trat in ihren Raum wie in die Dunkelkammer meiner Zukunft.

Ich stöberte in ihrem Atelier herum. Nicht dass ich etwas angefasst hätte, aber was da war, was offen dalag, das schaute ich mir an. Ich beugte mich über ihren Schreibtisch. Ich überflog mit dem Blick die Rücken der Ordner. Die Polaroids an der Pinwand mit den zerlaufenen Gesichtern übermütiger Freunde betrachtete ich einzeln und genau. Postkarten, angespitzte Bleistifte, zusammengeschobene Mappen aus milchigem Papier, mehrfach beschriebene Fotopapierschachteln im Regal. Kodak, Agfa, Fuji. Namen so aufregend wie Destinationen. Ebensogut hätte es heissen können: Chicago, Delhi, Bourg-sur-Saône. Es herrschte Ordnung. Eine Ordnung, die nicht mörderisch war, sondern den Wildwuchs erst ermöglichte. Es war die erste Ordnung in meinem Leben, die mir gefiel. Magisch angezogen von dieser Ordnung drehte ich in den Pausen meine Runden in ihrem Atelier. Ich horchte hinaus in den Flur. Auf das Knacken der Stiegen. Ich wäre nicht gern ertappt worden bei meinen Erkundigungen in einem Raum, in dem ich nichts verloren hatte. «Wem gehört das Atelier nebenan?», fragte ich eines Tages meine Arbeitgeberin. «Ah?» – «Das Atelier nebenan. Wem gehört es?» – «Ach so. Barbara. Barbara Davatz. Sie ist selten da, aber Du wirst sie sicher kennenlernen.»

Ich trat in ihren Raum wie in die Dunkelkammer meiner Zukunft.

Und eines Tages hing da ein Foto. Über den zusammengeschobenen Stativen das Bild. Ein Mann und eine Frau. Er mit kecker Haartolle als Latin-Lover und sie hineingegossen in seinen unsicht-

baren Arm. Sein Blick: Herausfordernd. Ihrer: Entrückt und theatral. Dass das Kunst war, wusste ich sofort. Falsch. Dass das Kunst war, wusste ich eben gerade nicht. Was sich mir eingrub als Empfindung war, dass mich dieses Bild durchlässig machte. Es perlte nicht ab wie all diese Illustrationen von Laokoon mit den Schlangen im Geschichtsbuch und den Fotos von Münzen mit den Konterfeis von Imperatoren. Wenn ich in den folgenden Tagen die Lider senkte, irrlichterten die beiden Gesichter über meine Netzhaut. Bin ich wie sie? Sind sie wie ich? Bin ich es wert, in der Galerie der Lebenden aufgenommen zu werden? Und immer der Drang: Ich möchte auch auf das Bild. Ich möchte auch als Abzug an einer Atelierwand hängen und mit einem einzigen Blick bei anderen so viel Verwirrung anrichten wie diese bei mir.

Ich trat in ihren Raum wie in die Dunkelkammer meiner Zukunft.

Die Jugend, schreibt Proust, leidet am Würgegriff der Anonymität. Als ich die ersten Fotos von Barbara Davatz sah, war ich knapp zwanzig und existierte nicht. Es machte mir Angst, dass ich meinen Tanten nichts zu erzählen haben würde. So halb und halb träumte ich noch von Diplomen, von einer Verlobung, einer Heirat und Kindern im Grünen. Und halb und halb nahm ich es den Portraitierten übel, dass sie mir nicht jene Bindung zeigten, zu der ich keinerlei Neigung verspürte, die ich aber trotzdem bestätigt haben wollte. Wilde Ehen waren das, schwule Paare womöglich und anarchische Duos. Die erste Vermutung, dass diese Bindungen nicht von Dauer sein würden, hat sich über die Jahre hinweg bestätigt. Ebenso wie mein Bedauern darüber im Laufe der Zeit geschwunden ist. Wer den Zerfall der Familie bedauert, unterschätzt den Gewinn freiwerdender Kräfte. Umgekehrt braucht man nicht der Ideologie des Augenblicks zu huldigen, um einzusehen, dass Dauer auch ihre Qualitäten hat. Was mich lebendig erhält, ist das Glühen der Pole. Der Wunsch, angesehen zu sein, hat sich gehäutet. Sehen, wie es ist. Der ungewöhnliche Blick von Barbara Davatz auf ihre Paare hat mich dokumentiert.

Out of the Darkroom

of My Future

NICOLE MÜLLER

What I knew were the Catholic youth groups, church on Sundays, and picture-book albums of the most beautiful roses. I knew the village and old Zumthor's blackberries. I remember him sitting on a bench in the sun keeping watch with a stick so that the little ones couldn't get at the ripe fruit. I knew the expression, "nibbling at the grass on the other side". Marriage was a holy sacrament and nobody gave a toss about the fact that being an artist was a thoroughly underpaid job. Art rarely made an appearance anyway, between manure piles and bell baptisms. The statement, "Now, there's an artist!" oozed condescension.

I walked into her space as if into the darkroom of my future.

I poked around her studio. Not that I would have touched anything, but I looked at what was there, open to view. I bent over her desk. I glanced at the spines of the file folders. Pinned on the wall, Polaroid pictures of boisterous friends with fading faces: I examined each one. Postcards, sharpened pencils, stacks of milky-paper sleeves, photo paper boxes on the shelves labelled several times over. Kodak, Agfa, Fuji. Names as exciting as destinations. They could easily have read: Chicago, Delhi, Bourg-sur-Saône. Order reigned. An order that wasn't killing but that invited rampant growth. It was the first order I'd ever liked. Magically attracted to it, I toured her studio in my breaks. I listened for sounds in the hall. The stairs creaking. I didn't want to be caught exploring a room I had no right to be in. "Who does that studio next door belong to?" I asked my boss one day. "Ah?" she said.—"The studio next door. Who does it belong to?"—"Oh. Barbara. Barbara Davatz. She's not there much but I'm sure you'll get to meet her."

I walked into her space as if into the darkroom of my future.

And one day a photograph was hanging there. Above the tripods stacked against the wall. A man and a woman. He a Latin lover with a jaunty quiff, she cradled in the mould of his invisible arm. His gaze challenging, hers enraptured and theatrical. I realised instantly that this was art. Wrong.

I didn't realise that it was art but only that I was struck by the feeling of being filled with a picture, of being permeable. It didn't bounce off like all those illustrations of Laocoon with his snakes in history books and the photographs of coins depicting emperors. When I closed my eyes in the days that followed, I would see the two faces flickering across my retina. Am I like them? Are they like me? Am I worth being added to the gallery of the living? And the incessant urge: I want to be in the picture, too. I also want to be a print mounted on the wall of a studio and have as disturbing an effect on other people as these two have had on me.

I walked into her space as if into the darkroom of my future.

Youth, Proust writes, suffers from the stranglehold of anonymity. When I first saw Barbara Davatz's photographs, I was barely twenty and didn't exist. I was afraid I wouldn't have anything to talk to my aunts about. So I still half dreamt of diplomas, getting engaged, married, raising children in the suburbs. And I half resented the fact that the sitters did not demonstrate the (family) ties I still wanted to have confirmed although they meant nothing to me. Reckless marriages they were, gay couples and anarchistic duos. Time substantiated my initial suspicion that these ties would not last. And time also erased my regret over their transience. Anyone who regrets the decay of the family underestimates the advantages of the forces thereby released. Conversely, there is no need to honour the ideology of the moment in order to appreciate the potential qualities of permanence. What keeps me going is the radiance of the poles. The desire to be seen has been shed. Seeing it as it is. With the exceptional gaze that Barbara Davatz focuses on her couples, she has also kept a record of me.

Translation: Catherine Schelbert

«Jedes Bild ist das Dokument einer Beziehung, die Summe der Bilder ist ein Zeitdokument.»

Portraits 1982, 1988, 1997 von Barbara Davatz

SIGRID PALLMERT

1982, 1988, 1997: sechs Jahre, neun Jahre, 15 Jahre liegen zwischen den genannten Jahrzahlen. Der Kalte Krieg ist vorbei, der Eiserne Vorhang gefallen, Regierungen wurden abgelöst, neue Regierungen sind an die Macht gelangt, die Globalisierung beherrscht die Welt, der Neoliberalismus breitet sich aus, das Private wird immer mehr öffentlich gemacht. In der Zwischenzeit wurde aber auch geboren, gelebt und gestorben, geliebt und gehasst, geheiratet und getrennt, Freundschaften wurden geschlossen, überdauerten oder wurden wieder aufgelöst.

Wenn die Zürcher Fotografin Barbara Davatz 1982 zwölf «Junge Paare» fotografiert, die sich in irgendeiner Form verbunden sind, seien sie verliebt, verheiratet, verwandt, befreundet, tritt sie ganz nah heran an den Menschen mit seinen Freuden und Leiden, seiner Biografie. Barbara Davatz bringt den Portraitierten – sie hat diese aus ihrer weiteren Umgebung rekrutiert – viel Sympathie entgegen, vor allem tritt sie aber mit dokumentarischem Interesse an die Personen heran – ohne reine Feldforschung zu betreiben. Entstanden ist eine Art Bestandesaufnahme schweizerischer Befindlichkeiten zu Anfang der achtziger Jahre. 1982 schreibt Barbara Davatz: «Die hier portraitierten jungen Menschen reagieren aufeinander und auf unsere Zeit, jede und jeder auf ihre/seine Art. Durch ihr äusseres Erscheinungsbild (Selbstdarstellung) vermitteln sie Informationen, die durch das ‹doppelte› Auftreten verstärkt werden. Sie verfolgen Moden, verwerfen sie, bekunden eine bestimmte Haltung, verkörpern etwas vom Zeitgeist in ihrem Äusseren.»[1] Und weiter: «Die Portraitierten solidarisieren sich so miteinander als Paar auf der persönlichen Ebene und zeigen eine Gruppenzugehörigkeit auf der sozialen Ebene.»[2]

Die streng konzeptuelle Fotoarbeit stellt allen Paaren denselben Rahmen zur Verfügung: die Anonymität des Fotostudios. Das Fehlen eines Umfeldes unterstützt den nüchternen Blick der Fotografin, reduziert auf das Wesentliche und lenkt die Sicht der Betrachterinnen und Betrachter unmittelbar auf die Portraitierten: ihre Erscheinung, ihre Körpersprache, ihre Beziehung zueinander. Die Bilder laden zur Interpretation ein, indem auf den Fotos die Mittel nonverbaler Kommu-

nikation ihre volle Wirkung entfalten. Roland Barthes' «Sprache der Kleidung» lässt sich bei Davatz' «Jungen Paaren» geradezu mustergültig abhandeln. Die Dargestellten sind sich der Signalwirkung ihrer Kleider sehr wohl bewusst. Entsprechend bewusst muss auch die Kleiderwahl am Morgen des Fototermins ausgefallen sein, wobei es bei diesem Prozess nicht darum ging, sich zu stylen. Beabsichtigt wurde wohl vielmehr, sich so zu präsentieren, wie man sich selber sieht, im Alltag, und nicht in Ausnahmesituationen. Silvia Bovenschen hält fest: «Indem eine Person sich jeden Tag aufs neue bekleidet, plaziert sie sich bewusst oder unbewusst täglich erneut an einem Schnittpunkt sehr heterogener gesellschaftlicher Codierungen – diese Codes können kultureller, ästhetischer oder sozial-stratifikatorischer Art sein.»[3]

Die Art des Ausschnitts der Fotos verweigert die Sicht auf ein Accessoire, das von höchster Wichtigkeit ist, was den Gesamthabitus anbelangt: die Schuhe. Nicht wenige Zeitgenossen bezeichnen sich als passionierte Schuhsammlerinnen und -sammler, deklarieren den Schuh zum Lieblingskleidungsstück und legen Wert darauf, dass die Schuhe von der Umgebung auch gebührend zur Kenntnis genommen werden. Obwohl auf den Fotos nicht sichtbar, sind die Schuhe aber sehr wohl spürbar, indem sie Einfluss nehmen auf die Körperhaltung der Trägerinnen und Träger. Zur Frage des Dreiviertelausschnitts meint Barbara Davatz: «Wenn man mehr Person zeigt, geht das auf Kosten der ‹Persönlichkeitsdarstellung›, der Ausstrahlung, die vom Gesicht ausgeht. Bei diesem Ausschnitt ist gerade genug ‹Körperlichkeit›, ohne eben das Gewicht des Gesichts zu mindern.»[4]

Die strikte Frontalität und der Blick in die Kamera betonen die absolute *Präsenz* der Portraitierten. Über diesen Blick in die Kamera hält die Fotografin fest: «Meiner Meinung nach vermag ein Bild mit ‹Blickkontakt› länger zu interessieren, und man bekommt selbstverständlich eher eine Ahnung davon, mit *wem* man es zu tun hat.»[5] Der Betrachter, die Betrachterin, tritt in einen Dialog mit den dargestellten Personen, fühlt sich ihnen nahe. Die Zweisamkeit des Doppelportraits wird relativiert, weil das symbiotische Moment des sich zugewandten Paares entfällt. Barbara Davatz scheidet Fotos, die allzu «kuschelig» daherkommen, aus; «dies hätte eine Inszenierung zur Folge gehabt, die dem dokumentarischen Grundkonzept nicht entsprochen hätte.»[6]

Gerade bei jungen Menschen spielen die Kleider bei der Identitätssuche eine zentrale Rolle. Das Finden des eigenen Stils, das Gefühl der Gruppenzugehörigkeit oder die bewusste Abgrenzung sind Schritte in dieser Suche. Für den Soziologen Georg Simmel ist die Spannung zwischen dem Bedürfnis nach «sozialer Anlehnung» und dem Bedürfnis nach «Absonderung» Ursprung und Motor des Modeverhaltens.[7] Das Doppelportrait, der Doppelauftritt als kleinstmögliche Form der Gruppe, wirft die Frage nach Individualität und Gruppenzugehörigkeit in besonderem Masse auf. Bei Paaren und Befreundeten lässt sich auch immer wieder feststellen, dass die Partner über denselben Attraktivitätsgrad verfügen – sich manchmal sogar gleichen – und denselben Kleiderstil bevorzugen. Kleidung als Teil und Ausdruck unserer Identität sendet an unsere Umgebung Botschaften aus, die begierig aufgenommen werden. Und die Autoren Carlo Michael Sommer und Thomas Wind halten richtigerweise fest: «Je mehr wir von einem Menschen wissen, je länger wir ihn kennen, desto weniger Gewicht haben die Kleiderbotschaften.»[8] Für die Betrachter der Fotos von Davatz bilden die Kleider neben der Körperhaltung den Schlüssel zur Persönlichkeit der Portraitierten, wobei sich die Decodierung häufig als schwierig gestaltet, weil mittels kleinster Differenzierungen unterschiedlichste Botschaften kommuniziert werden.

1988 konkretisiert sich im Gespräch zwischen Barbara Davatz und Walter Keller, dem damaligen Herausgeber der Zeitschrift «Der Alltag», die Idee, «in einer Neuauflage die gleichen Menschen wieder ins Studio einzuladen und sie noch einmal zu fotografieren. Wer wollte, konnte eine neue Partnerin oder einen neuen Partner mitbringen.»[9] Unverzüglich schreitet Barbara Davatz zur Realisierung, und das Resultat wird im «Alltag» publiziert. Der Untertitel der Zeitschrift «Die Sensationen des Gewöhnlichen» fasst das Resultat aufs sprechendste zusammen. Eben gerade die Begegnung mit dem Alltäglichen bringt Überraschendes, Irritierendes zutage. Die Fotografin konfrontiert die zu Portraitierenden mit denselben Voraussetzungen wie 1982, was den direkten Vergleich der beiden Jahrgänge ermöglicht. «Die Archäologie des Lifestyles unserer Zeit schreibt sich gleich selbst in diesen Bildern»[10], meint Walter Keller über die «Bildfolgen der Zürcher Fotografin Barbara Davatz, eine kleine Studie übers Älterwerden». Barbara Davatz hat diese Arbeit auch schon mit «As Time Goes By» betitelt. Die Fotografie als unmittelbares Medium, das wir gewohnt sind zu lesen, zwingt uns im vorliegenden Falle zu höchster Konzentration. Jedes Detail gilt es zu beachten, das Barbara Davatz mit ihrem fast naturwissenschaftlich inspirierten Blick eingefangen hat. Der Zeitgeist der achtziger Jahre, bzw. sein Wandel im Laufe des Jahrzehnts, kristallisiert sich quasi in zwölf Doppelportraits von 1982 und 15 Doppelportraits und einem Dreierportrait (mit Kind) von 1988. Sieben «Junge Paare» treten in derselben Zweierkonstellation auf, verspüren also den Wunsch, die Kontinuität ihrer Beziehung dokumentieren zu lassen. Fünf «Paare» haben sich in der Zwischenzeit getrennt; jede Person der getrennten Paare bringt – mit einer einzigen Ausnahme – einen neuen Partner/eine neue Partnerin zum Shooting. Die Themen Älterwerden und Sich-Trennen werden durch die Konfrontation der Serie von 1988 mit derjenigen von 1982 ganz augenfällig. Die Betrachter der Fotos finden sich versucht, über die «Jungen Paare» Spekulationen anzustellen, über die Trennung in Zeiten der hohen Scheidungsraten zu philosophieren. Das Thema des Älterwerdens äussert sich in subtilerer Form, und bei vielen, noch sehr jungen Portraitierten geht es doch noch eher um das Erwachsenwerden denn um das Älterwerden, wobei das erstere das letztere automatisch mitbeinhaltet.

1996 entschliesst sich Barbara Davatz, die über Jahre geplante Weiterführung der «Junge Paare»-Reihe in Angriff zu nehmen. Das zeitraubende Unterfangen kommt im Frühling 1997 zu seinem Abschluss und wird darauf in der Sonderausstellung «Modedesign Schweiz 1972–1997» im Schweizerischen Landesmuseum in Zürich gezeigt. Da mit dem Begriff «Paar» fast automatisch das Liebespaar suggeriert, bzw. assoziiert wird, benennt Barbara Davatz die Arbeit in «Portraits» um. Das Aneinanderreihen der drei Jahrgänge ergibt, ausgehend von den ursprünglichen zwölf Doppelportraits, «Stämme» von drei bis sieben Fotos. Die zwölf «Stämme» umfassen insgesamt 51 Fotos. Fast episch breiten sich die Fotos vor uns aus, die verschiedenste Geschichten erzählen, um sich in ihrer Gesamtheit zur Geschichte zu verdichten. Barbara Davatz formuliert dazu treffend: «Jedes Bild ist das Dokument einer Beziehung, die Summe der Bilder ist ein Zeitdokument.»[11] Die einzelnen Biografien in ihrer Durchmischung setzen sich zu einem Bilderbogen zusammen, der auch Abbild unserer Gesellschaft ist. Es wird nachvollziehbar, wie sehr sich die traditionellen Formen des Zusammenlebens zugunsten neuer Beziehungsformen verändert haben. Der rasche gesellschaftliche Wandel bedingt laufend Neu- und Umorientierungen, ein Agieren und Reagieren. Die 15 Jahre an Lebenserfahrung haben neue An- und Einsichten mit sich gebracht.

Das bereits vor langer Zeit deklarierte Ende des Modediktats leistet der Pluralisierung Vorschub; Ted Polhemus glaubt, dass diese Tendenz ein «style surfing» bewirkt.[12] In der Fotoarbeit von Barbara Davatz wird ganz offensichtlich, dass die Mode seismographisch auf den Zeitgeist reagiert. So hält Barbara Vinken fest: «Am Ende des 20. Jahrhunderts ist die Mode geworden, was die Kunst hätte sein wollen: In ihr kommt der Zeitgeist zur Darstellung.»[13] Und Silvia Bovenschens Aussage, dass «(...), indem die Mode uns die verflossene Lebenszeit stationenhaft veranschaulicht, provoziert sie die Frage nach dem Ende des Metamorphosenspiels, das sie mit uns treibt»[14], könnte man direkt auf die Fotoarbeit von Barbara Davatz übertragen. Die Subkulturen und die Strassenmode haben der Mode in den letzten Jahrzehnten entscheidende Impulse gegeben. Sich gegen Kategorisierungen wehrend, begeben sich immer mehr Menschen auf die Suche nach einem authentischen Stil. Ted Polhemus fasst zusammen: «If today more and more people use their dress style to assert: ‹I am authentic›, it is simply evidence of our hunger for the genuine article in an age which seems to so many to be one of simulation and hype.»[15]

1973 erstellte Barbara Davatz das «Portrait einer Schweizer Firma». Die ganze Belegschaft der Firma H. Walser, Textildruckerei und Zwirnerei, in Zürchersmühle/AR holte die Fotografin direkt von der Arbeit vor die Kamera – 38 Personen. Zu jeder Fotografie wurden Vorname und Name, Geburtsdatum, Nationalität sowie Beruf oder Beschäftigungsbereich der oder des Portraitierten vermerkt. Entstanden ist eine Fotoarbeit von grösster Eindringlichkeit, unspektakulär, vielschichtig und kraftvoll, unsentimental, von sozialem Engagement, ohne explizit darauf hinzuweisen: eine Momentaufnahme schweizerischer Alltagsrealität. Die «Portraits 1982, 1988, 1997» – im Unterschied zur Arbeit aus dem Jahre 1973 ein work in progress – zoomen auf Personen in drei verschiedenen Lebensphasen, nicht im Arbeitsgewand, sondern im Outfit, nicht Arbeiterinnen und Arbeiter, sondern eher die sogenannt Privilegierten, deren Beruf häufig Berufung ist; anstelle von ausführlicheren biografischen Angaben ist der Vorname getreten. Das Psycho- und Soziogramm eines Segments der schweizerischen Bevölkerung präsentiert sich in den «Portraits 1982, 1988, 1997» von Barbara Davatz und erschliesst uns eine Welt, die ist wie die unsrige, aber auch wieder anders, eingefangen in konsequenter und faszinierender Weise.

1 Barbara Davatz: Bildfolgen der Zürcher Fotografin Barbara Davatz, eine kleine Studie übers Älterwerden, in: Der Alltag, Zürich 1988/2, S. 167.
2 Begleittexte von Barbara Davatz zu ihren Ausstellungen.
3 Silvia Bovenschen (Hrsg.), Die Listen der Mode, Frankfurt/M. 1986, S. 19.
4 Schriftliche Antwort auf von der Autorin erstellten Fragebogen, April 1999.
5 Siehe Anm. 4.
6 Siehe Anm. 4.
7 Zitiert nach Carlo Michael Sommer/Thomas Wind, Mode: Die Hüllen des Ich, Weinheim/Basel 1988, S. 104.
8 Siehe Anm. 7, S. 20.
9 Siehe Anm. 1.
10 Siehe Anm. 1.
11 Einführungstext der Fotoarbeit «Portraits 1982, 1988, 1997» in der Ausstellung «Modedesign Schweiz 1972–1997» im Schweizerischen Landesmuseum Zürich.
12 Ted Polhemus, Style Surfing: What to Wear in the 3rd Millennium, London 1996.
13 Barbara Vinken, Mode nach der Mode: Kleid und Geist am Ende des 20. Jahrhunderts, Frankfurt/M. 1993, S. 35.
14 Siehe Anm. 3, S. 20.
15 Ted Polhemus, Street Style: From Sidewalk to Catwalk, London 1994, S. 7.

"Every picture is the record of a relationship; the sum of the pictures is a record of time."

Portraits 1982, 1988, 1997 by Barbara Davatz

1982, 1988, 1997: six years, nine years, and fifteen years lie between these three dates. The cold war is over, the iron curtain has dropped, governments have been replaced, new governments are in power, globalisation dominates the planet, neoliberalism is spreading, and private worlds are becoming ever more public. But, in the meantime, women have given birth, people have lived and died, loved and hated, married and divorced, made friends and lost them.

In 1982, the Zurich photographer Barbara Davatz takes pictures of twelve "Young Couples" who are linked in some way—through love, marriage, kinship, friendship. In so doing, she moves very close to them, close to their joys and sorrows and their personal biographies. Barbara Davatz approaches her sitters, recruited from the world around her, with great fellow feeling but above all with documentary interest—but without conducting pure field research. The outcome is a case study that reports on the prevailing mood in Switzerland at the beginning of the eighties. In 1982 Barbara Davatz writes: "The people portrayed here react to each other and to the times, each in their own way. Their looks (as they present themselves) convey information that is heightened by the 'double' portraits. They follow fashions, discard them, act out a specific attitude, and embody something of the zeitgeist in their appearance."[1] And further: "The sitters thus show the mutual solidarity of a couple on the personal level and identification with a group on the social level."[2]

The strictly conceptual photographic series establishes the same point of departure for all of the couples: the anonymity of the studio. The lack of a context underscores the photographer's matter-of-fact regard, reduces its object to the essentials, and focuses the gaze of her viewers exclusively on the sitters: their appearance, their body language, their relationship to each other. By giving free rein to non-verbal communication, these photographs invite us to do our own interpreting. Davatz's "Young Couples" is an embodiment par excellence of Roland Barthes's "Système

de la Mode". The sitters are fully aware of the signal impact of their clothing. And they assuredly made their selection with due care on the morning of the photo session, though not in order to be smart. On the contrary, their objective is to exemplify how they see themselves in daily life rather than in an exceptional situation. In the words of Silvia Bovenschen: "By putting on new clothes every day, people daily situate themselves consciously or unconsciously at the interface of extremely heterogeneous social coding—these codes may be cultural, aesthetic, or indicative of social stratification."[3]

The photographs are framed in such manner as to deprive us of a highly significant accessory as regards overall appearance: the shoes. Not a few contemporaries are devoted to footwear, passionately collecting shoes, declaring them to be their favourite article of clothing, and making sure they are suitably appreciated. Although not seen in the photographs, they are clearly felt, inasmuch as they influence the posture of their wearers. Regarding the choice of a three-quarter portrait, Barbara Davatz remarks, "Showing more of the sitters would detract from the 'representation of personality', from the aura radiated by their faces. This framing shows just enough of the body without diminishing the importance of the face."[4]

The absolute *presence* of the subjects is emphasised by the fact that they are photographed head on and looking directly into the camera. About the gaze of her subjects, the photographer says, "To my mind a picture with direct 'eye contact' holds one's interest longer and, of course, it makes it easier to sense *who* it is that we are facing."[5] Viewers enter into a dialogue with the people in the pictures, they feel close to them. The twosomeness of the double portrait is undermined because the symbiotic aspect of the mutual couple becomes inoperative. Barbara Davatz discards photographs that are too 'cuddly'; "this would have entailed posing that was at odds with the basic documentary concept."[6]

For young people especially, clothes play a central role in their search for an identity.[7] Finding a style of one's own, identifying with a group, or consciously setting oneself apart are steps in this search. The sociologist Georg Simmel sees the tension between the need for "social backing" and the need to be "apart" as the source and motivation of fashion behaviour. The double portrait, the twosome as the smallest possible group, lends a special edge to the question of individuality and group identification. Among couples and friends, one can observe time and again that the two partners are attractive to a similar degree, sometimes even resembling each other—and that they cultivate the same clothing style. Clothes as part of our identity send out messages that are eagerly taken in by our environment. As the writers Carlo Michael Sommer and Thomas Wind accurately observe: "The more we know about a person, and the longer we are acquainted, the less weight do fashion messages carry."[8] In viewing Davatz's photographs, clothes in addition to physical posture are the key to the personalities of her subjects, although decoding them is frequently no mean task since the smallest variation may communicate an entirely different message.

In 1988 the idea of inviting the same people back to the studio for a second portrait acquires concrete shape in a conversation between Barbara Davatz and Walter Keller, then editor of "Der All-tag". Those who wanted to could bring a new partner along.[9] Davatz immediately tackles the pro-

ject and the result is published in "Der Alltag" that same year. The subtitle of the periodical, "the sensations of everyday life", eloquently summarises the outcome. Encounters with ordinary life are indeed a rich source of startling and thought-provoking insights. The photographer confronts her sitters with the same parameters as in 1982 to enhance direct comparison between the two sessions. "The archaeology of the lifestyle of our time is inscribed in these pictures,"[10] Walter Keller writes about the "series by the Zurich photographer Barbara Davatz, a pithy study on ageing". Barbara Davatz has also entitled this project "As Time Goes By". We are perfectly used to reading the direct medium of the photograph but, in this case, the photographer compels us to muster the utmost concentration. Every detail captured by Davatz's near scientific gaze demands attention. The zeitgeist of the eighties, or rather its transformation in the course of the decade, is crystallised, as it were, in twelve double portraits of 1982 and 15 double portraits plus a trio (couple with child) of 1988. Seven "Young Couples" appear in the same combination, indicating the desire to document the continuity of their relationship. Five pairs have since separated, each of the 'halves' coming to the shooting session with a new partner, with one exception. On comparison of the 1982 and 1988 series, the themes of ageing and separating surface with unmistakable clarity. We are tempted to speculate on the "Young Couples", and to philosophise on the factor of separation in an era of high divorce rates. The theme of ageing is couched in more subtle terms; the very young pairs are more concerned with adulthood than with ageing although the former automatically includes the latter.

In 1996 Barbara Davatz decides to act on the long cherished plan of producing a third series. The time-consuming undertaking is completed in the spring of 1997 and on view that year in the exhibition, "Modedesign Schweiz 1972–1997", at the Swiss National Museum. Since the term "couple" inevitably seems to connote a pair of lovers, Davatz renamed her project "Portraits". The juxtaposition of the three series, starting with the original twelve portraits, yields "family trees" of three to seven photographs each: 51 photographs altogether. The almost epic spread of pictures tells a host of different stories, condensed in their totality into the history of a fifteen-year time span. In Barbara Davatz's own precise words: "Every picture is the record of a relationship; the sum of the pictures is a record of time."[11] The ingredients of the single biographies merge into a picture of our society. We realise the extent to which traditional forms of joint living have changed and given way to new types of relationships. Rapid social change necessitates constant orientation and re-orientation, action and reaction. Fifteen years of life experience have revealed new outlooks and insights.

The much vaunted end of the fashion dictate has lent impetus to pluralisation; Ted Polhemus believes that this tendency has led to "style surfing".[12] In Barbara Davatz's photographs, it becomes quite obvious that fashion is a seismographic response to the zeitgeist. Barbara Vinken remarks: "At the end of the 20th century, fashion has become what art wanted to be: it is a representation of the zeitgeist."[13] And when Silvia Bovenschen writes that "…by illustrating the stations involved in the passing of lives and times, fashion provokes the question of whether the game of metamorphosis that it plays with us has come to an end",[14] she could be speaking directly about Barbara Davatz's photography. Subcultures and street fashion have given fashion its decisive impulses over the past few decades. In opposition to categorisation, more and more people are trying to find an authentic style. Ted Polhemus explains: "If today more and more people use their dress

style to assert: 'I am authentic', it is simply evidence of our hunger for the genuine article in an age which seems to so many to be one of simulation and hype."[15]

In 1973 Barbara Davatz made a "Portrait of a Swiss Company". She took each of the employees at H. Walser Textile Printers and Twisting Mill in Zürchersmühle in the Canton of Appenzell straight from their jobs and placed them in front of the camera—38 people. Every portrait is labelled: first name, last name, date of birth, nationality, and job title or area of work. The outcome is a work of the greatest urgency, unspectacular, complex and compelling, unsentimental and socially committed without being obtrusive: candid shots of an ordinary Swiss reality. "Portraits 1982, 1988, 1997"—a work in progress in contrast to the 1973 project—zooms in on people in three different phases of their lives, not in their work clothes, but dressed to go out, not working-class but so-called privileged people, whose jobs often coincide with their private passions; biographical details have been reduced to the sitter's first name. The psycho- and sociogramme of a segment of the population in Switzerland, presented in "Portraits 1982, 1988, 1997" by Barbara Davatz, reveals a world to us that resembles our own but is different nonetheless, a world captured with a fascinatingly consistent reduction of means.

Translation: Catherine Schelbert

1 Barbara Davatz: "Bildfolgen der Zürcher Fotografin Barbara Davatz, eine kleine Studie übers Älterwerden", in: Der Alltag, Zurich 1988/2, p. 167.
2 Barbara Davatz in the text she has written to accompany her exhibitions.
3 Silvia Bovenschen (ed.), Die Listen der Mode, Frankfurt/M. 1986, p. 19.
4 Written response to the author's questionnaire, April 1999.
5 See note 4.
6 See note 4.
7 Carlo Michael Sommer/Thomas Wind, Mode: Die Hüllen des Ich, Weinheim/Basel 1988, p. 104.
8 See note 7, p. 20.
9 See note 1.
10 See note 1.
11 Introductory text to "Portraits 1982, 1988, 1997" in the exhibition "Modedesign Schweiz 1972–1997" at the Swiss National Museum in Zurich.
12 Ted Polhemus, Style Surfing: What to Wear in the 3rd Millennium, London 1996.
13 Barbara Vinken, Mode nach der Mode: Kleid und Geist am Ende des 20. Jahrhunderts, Frankfurt/M. 1993, p. 35.
14 See note 3, p. 20.
15 Ted Polhemus, Street Style: From Sidewalk to Catwalk, London 1994 p. 7.

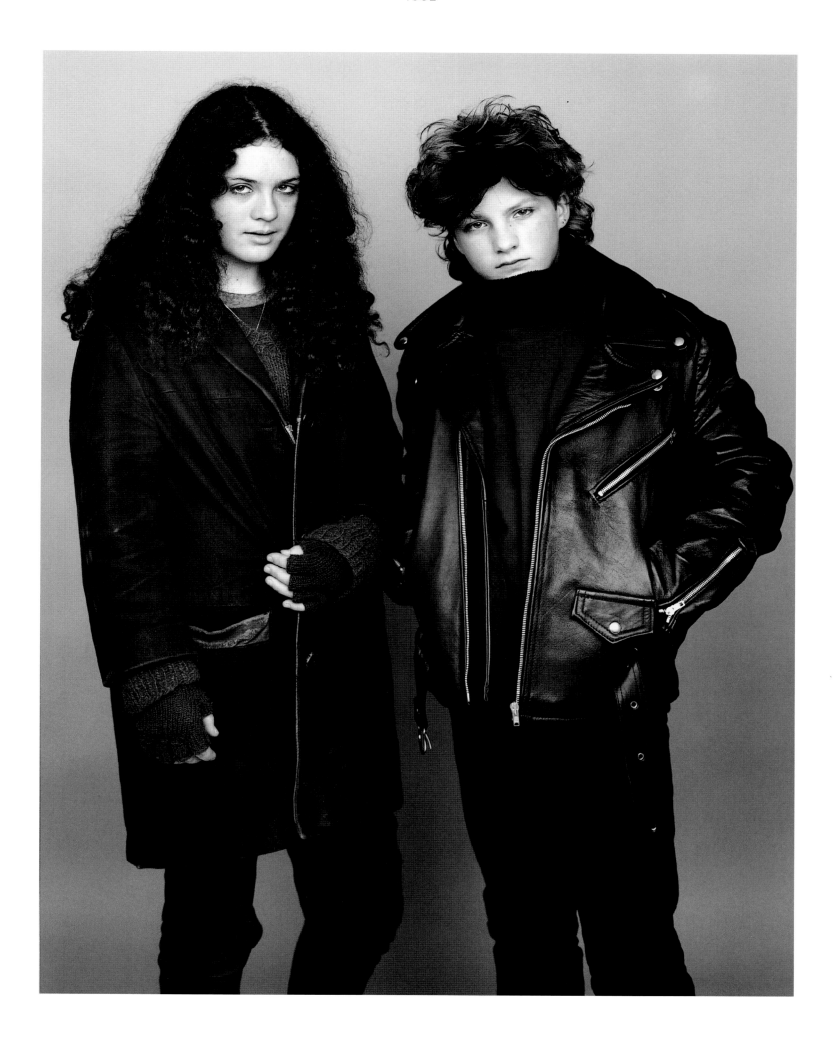

CAROLE SERGE

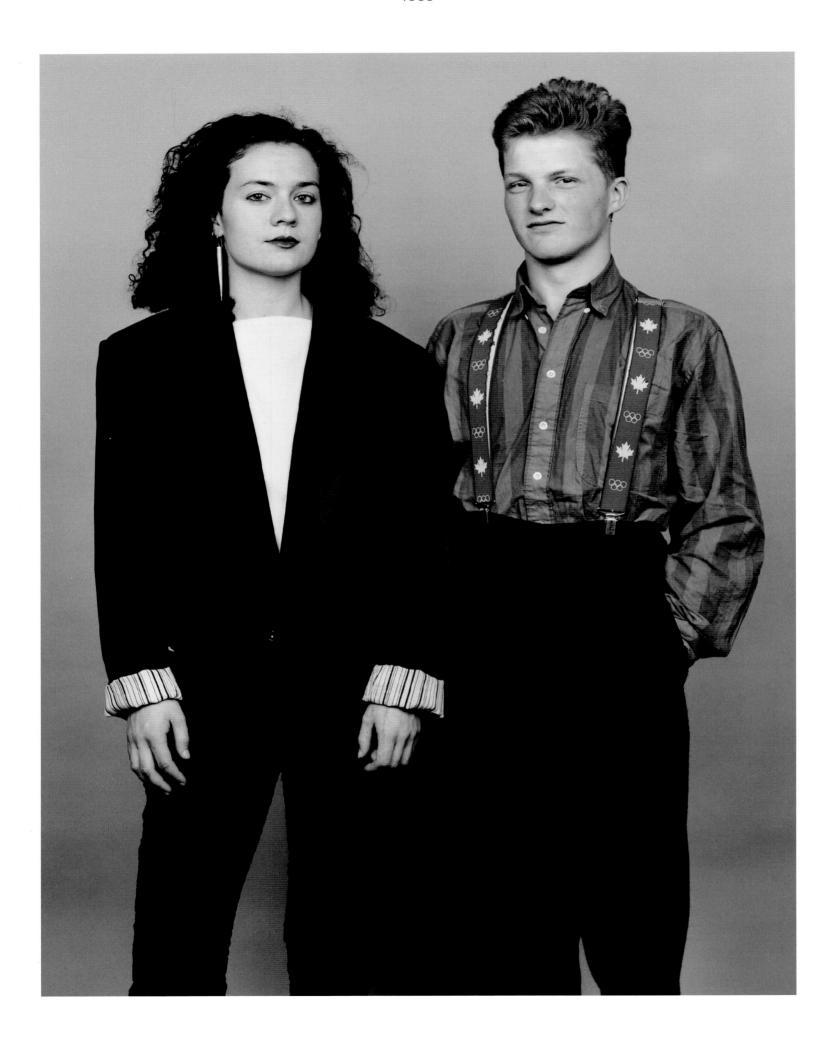

CAROLE SERGE

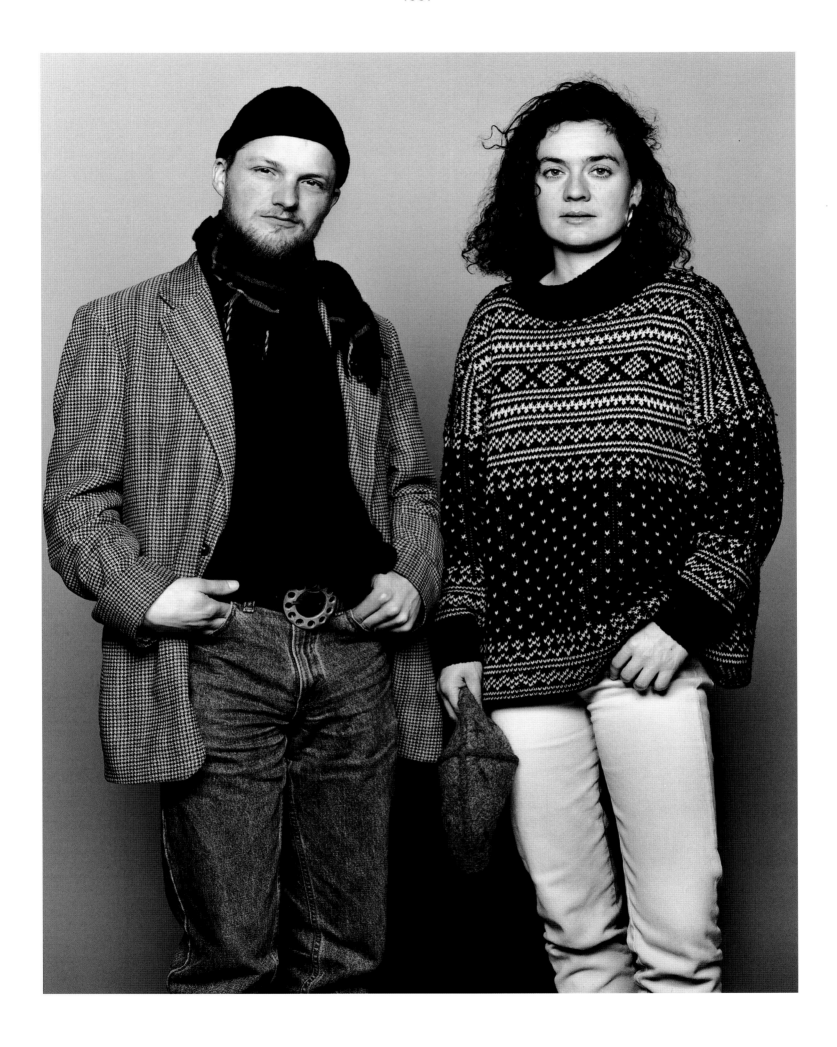

SERGE CAROLE

1982

CAROLE SERGE

1988

CAROLE SERGE

1997

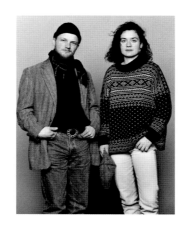

SERGE CAROLE

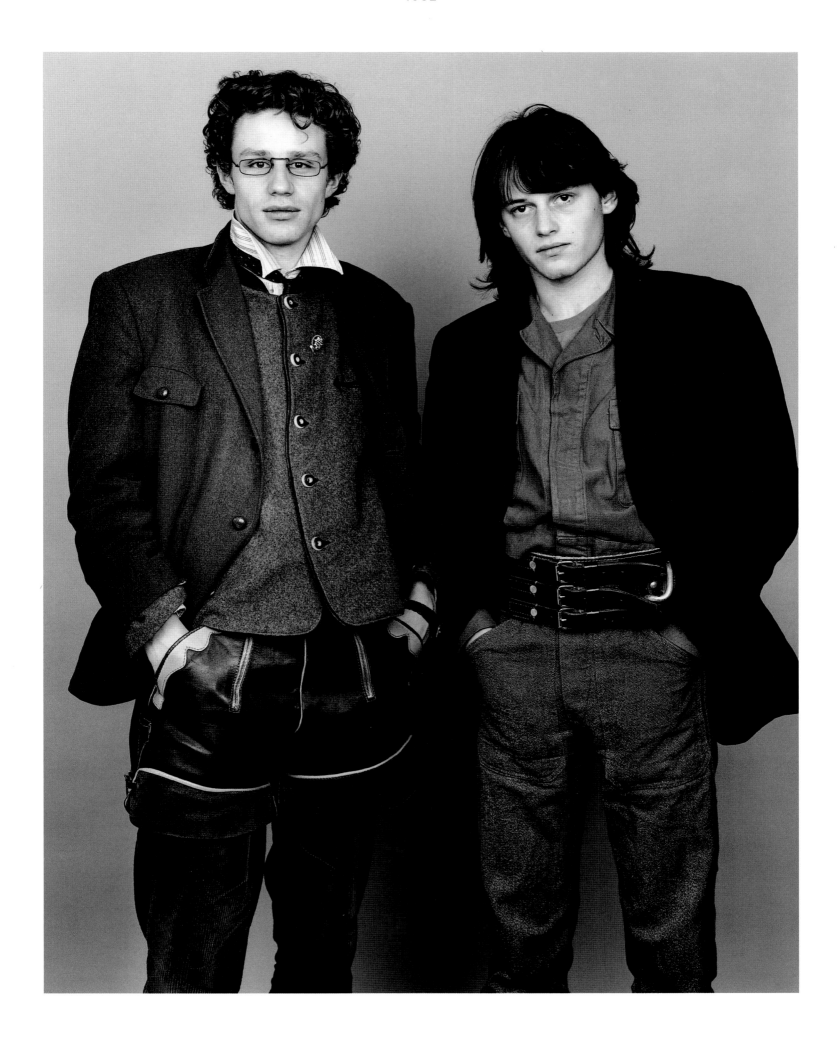

FRANZ MATTHIAS

1988

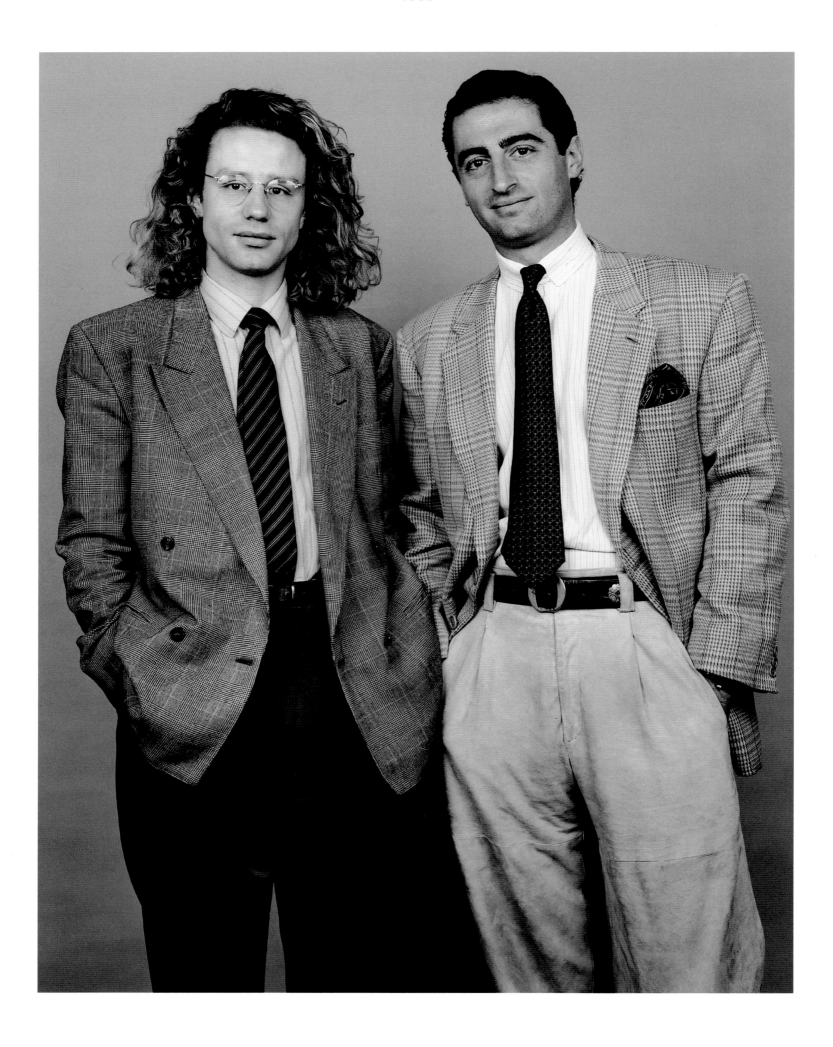

FRANZ

RAFAEL

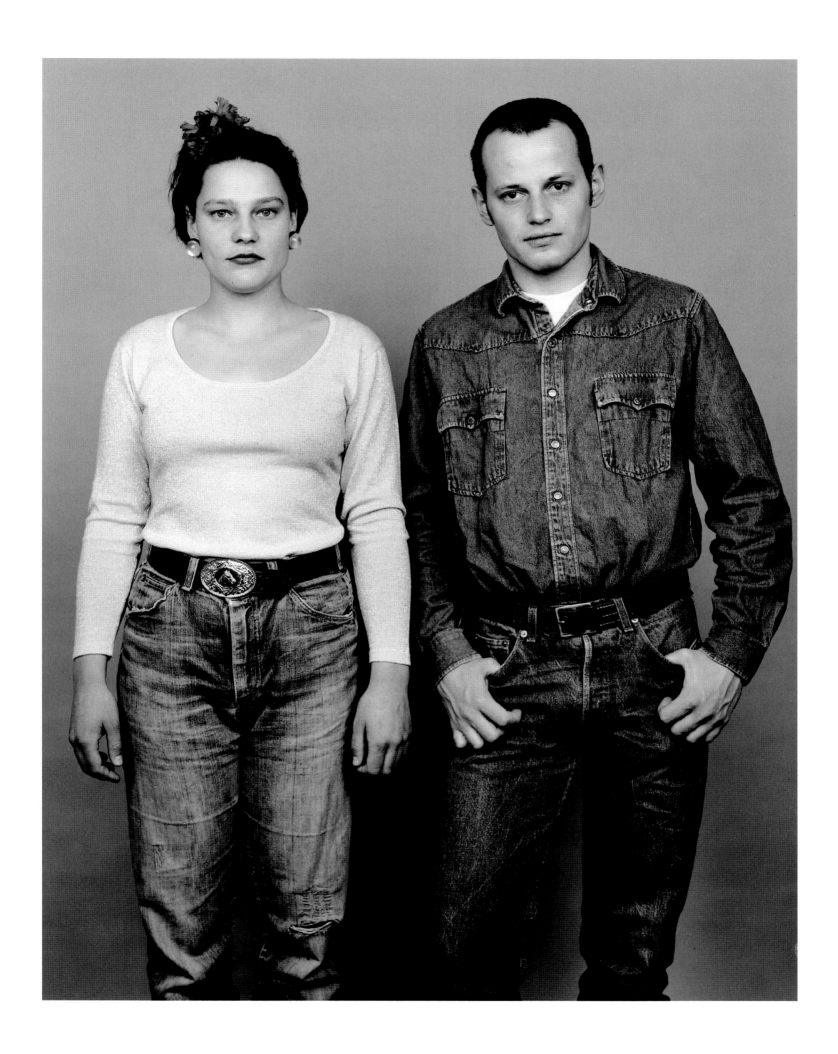

SONNHILD MATTHIAS

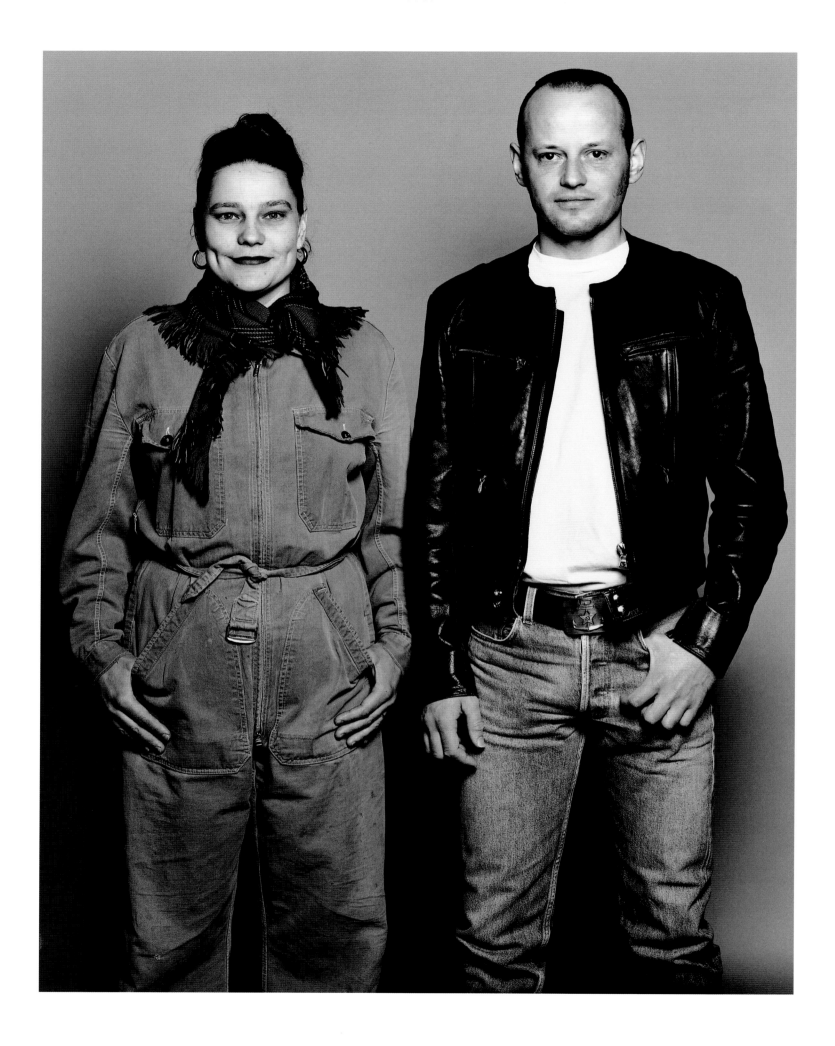

SONNHILD MATTHIAS

1982

FRANZ MATTHIAS

1988

 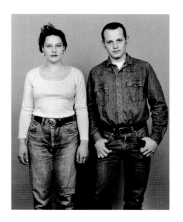

FRANZ RAFAEL SONNHILD MATTHIAS

1997

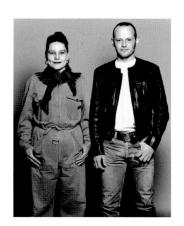

SONNHILD MATTHIAS

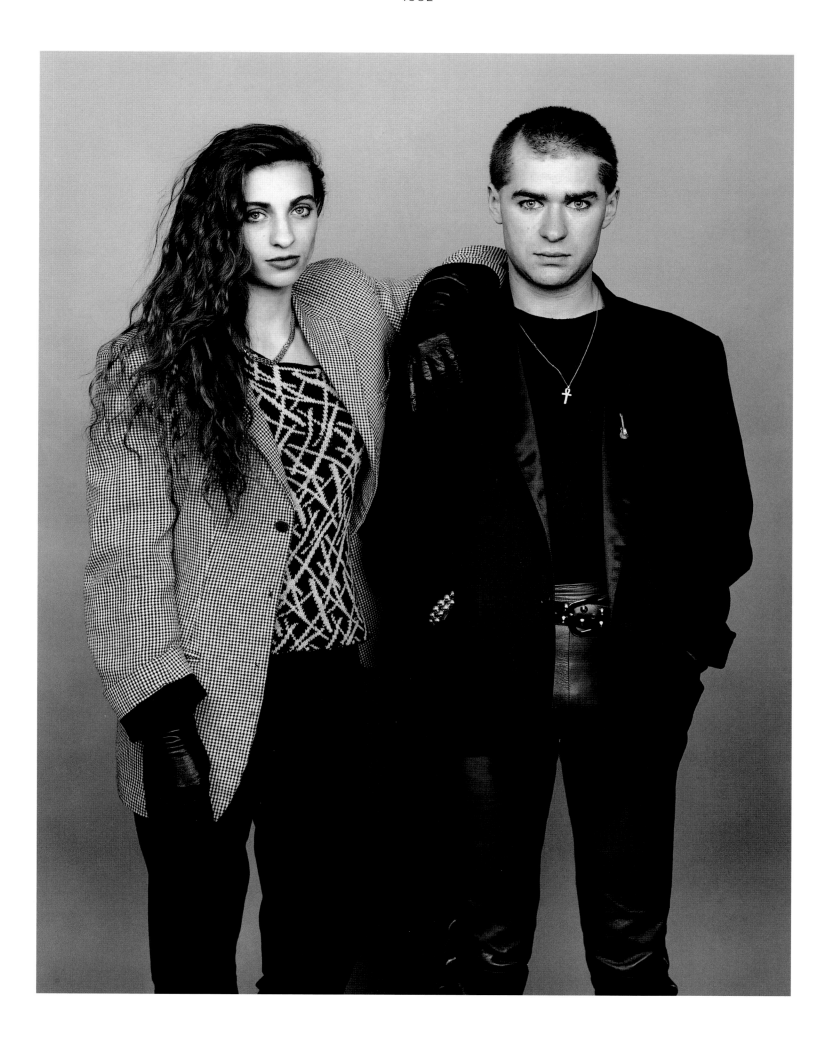

BIANCA ERNESTO

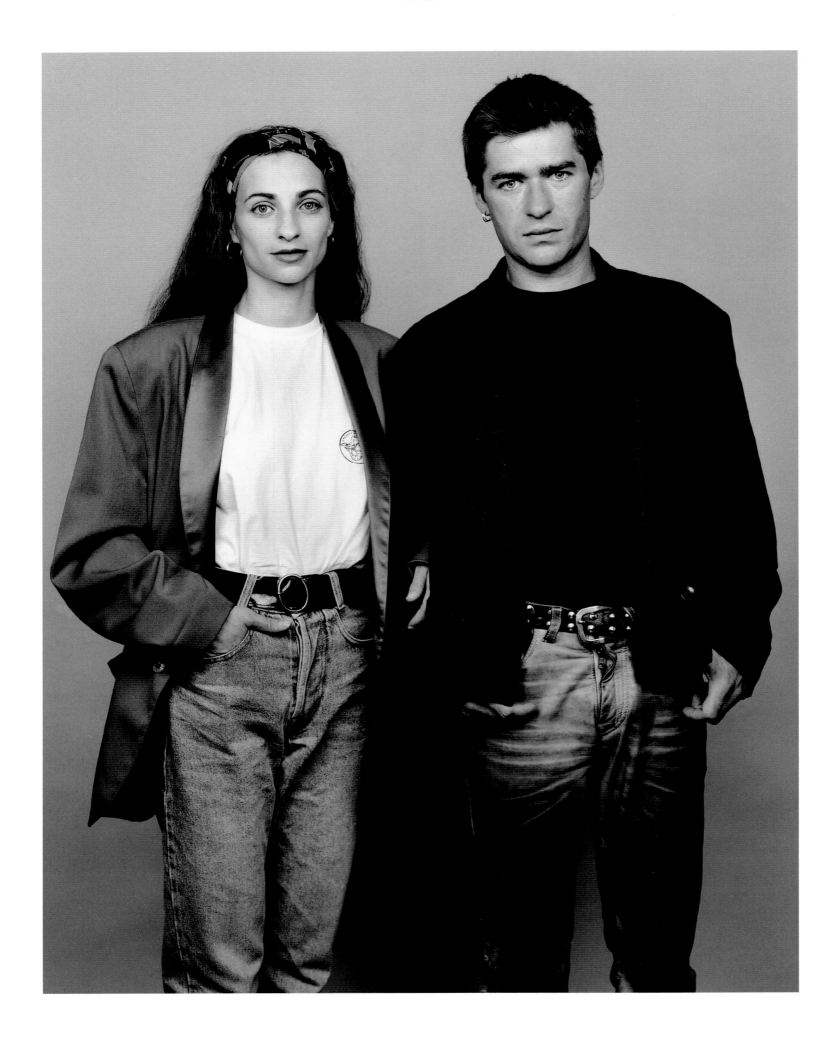

BIANCA ERNESTO

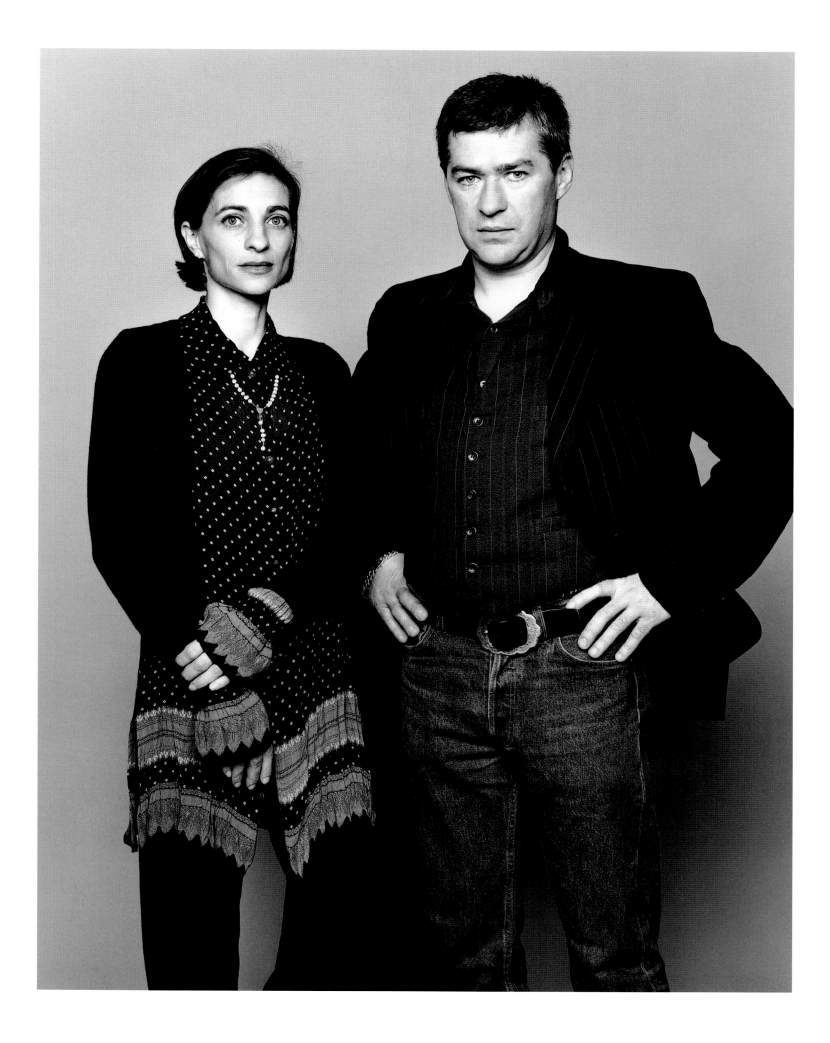

BIANCA ERNESTO

1982

BIANCA ERNESTO

1988

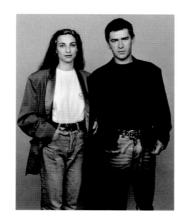

BIANCA ERNESTO

1997

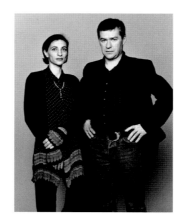

BIANCA ERNESTO

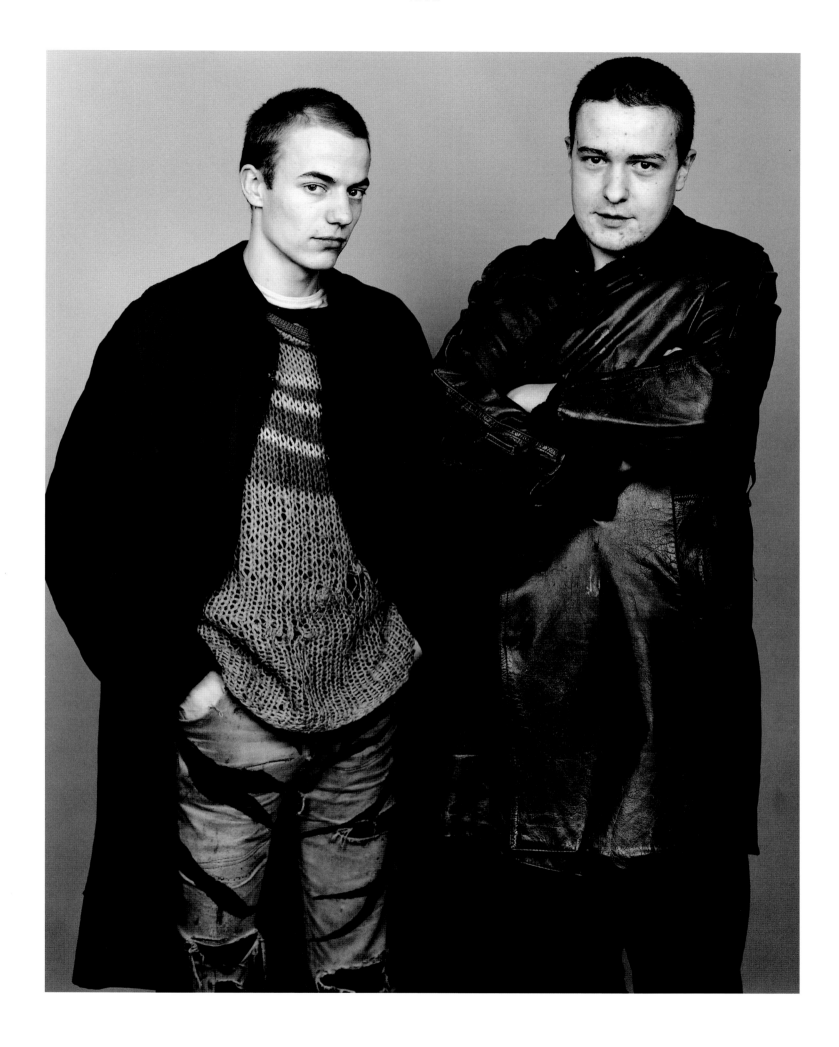

BENI ANDI

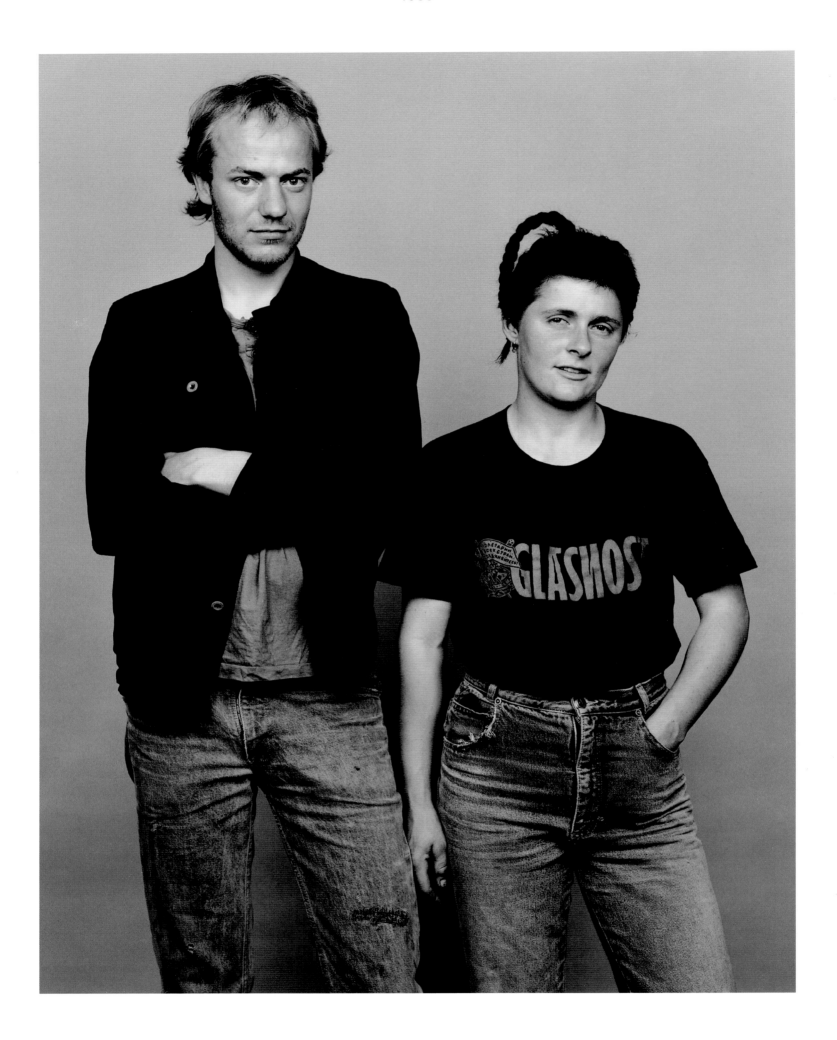

BENI

CAROLA

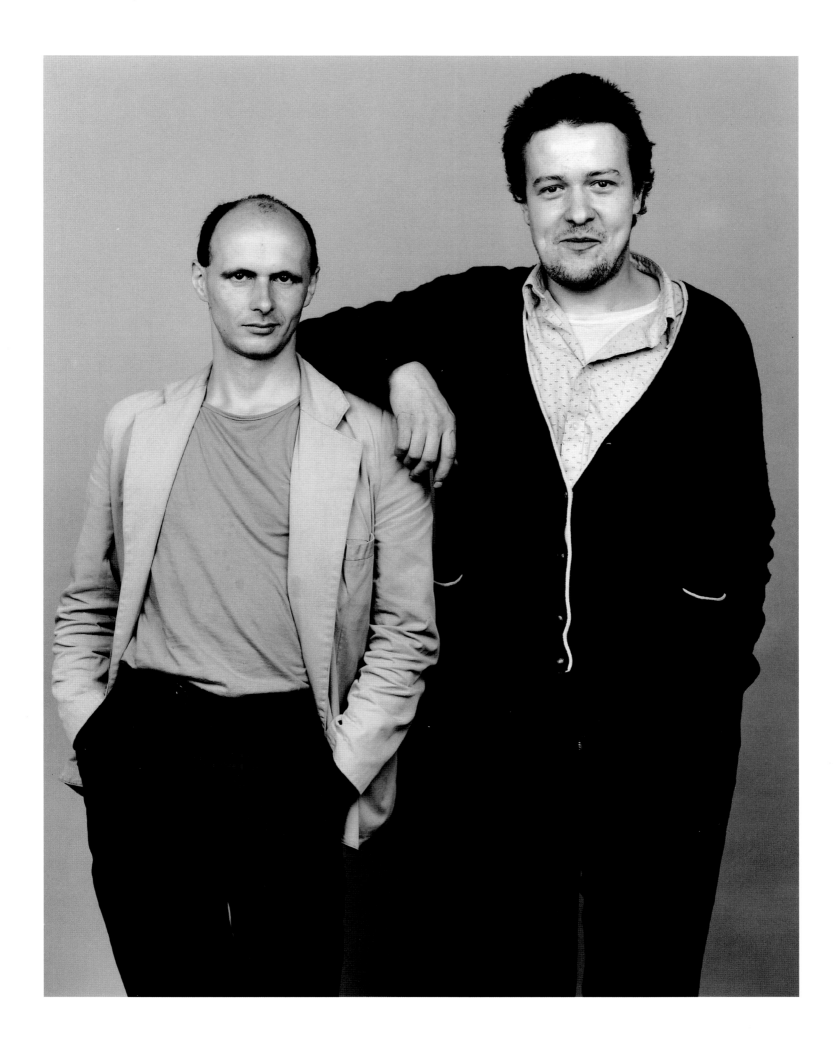

HEINI ANDI

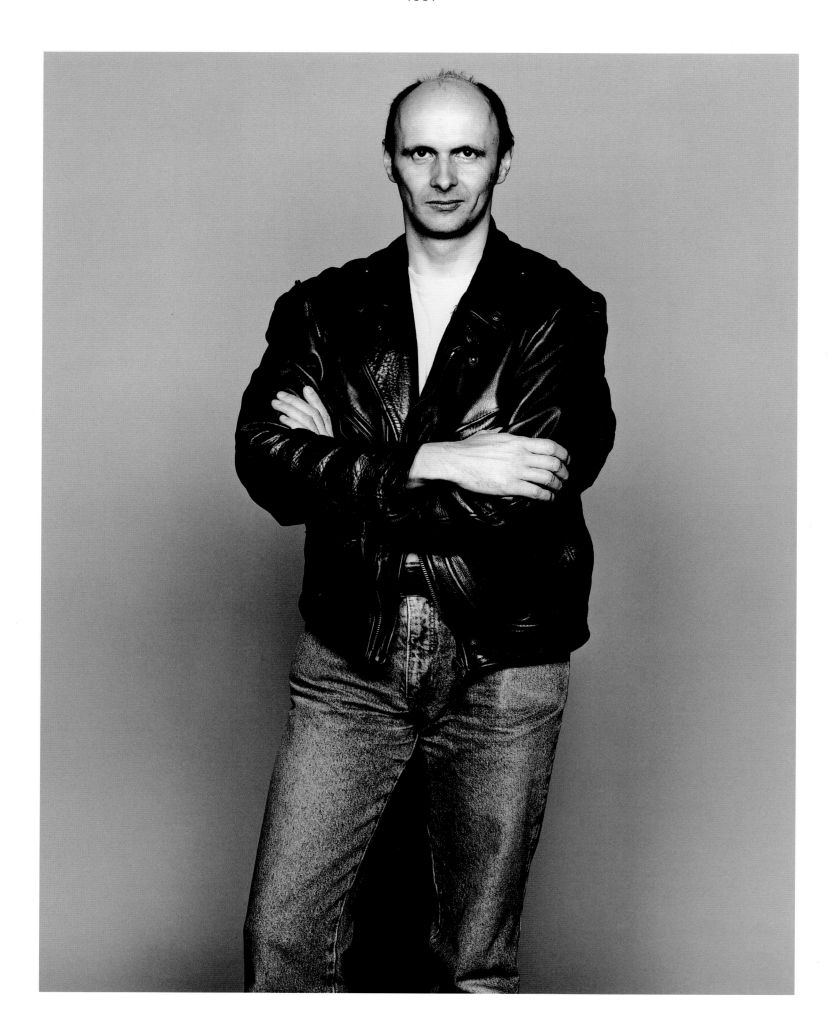

HEINI

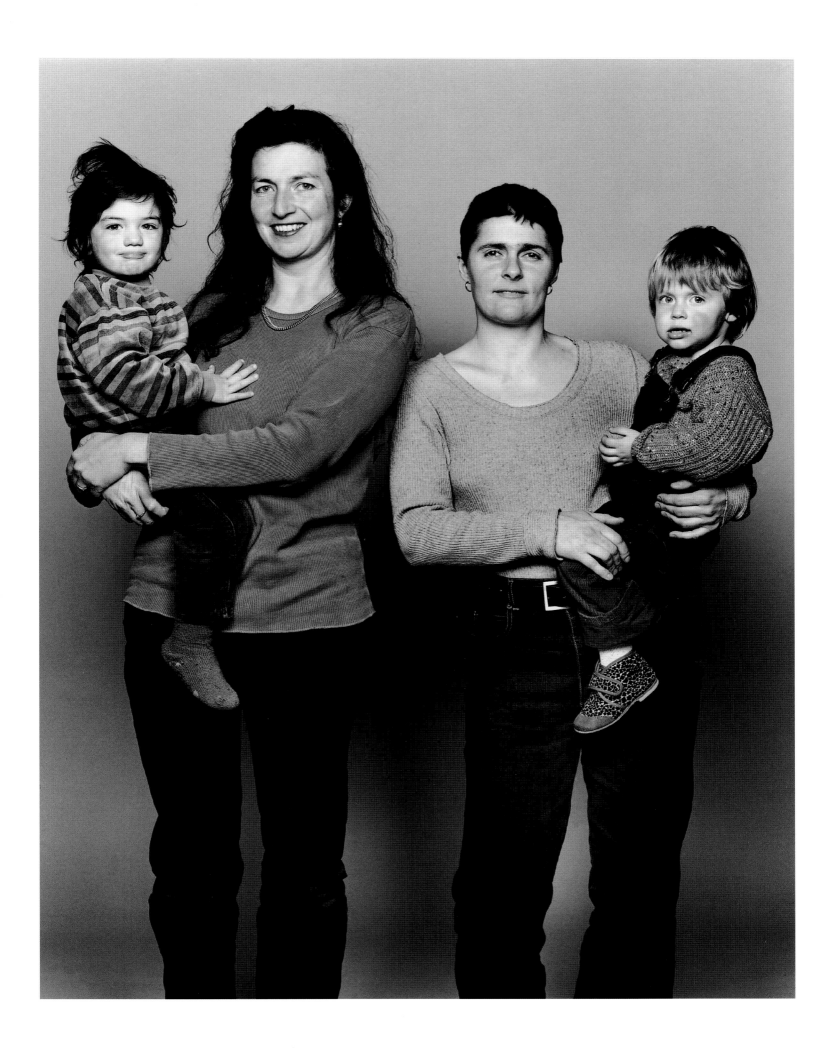

LUCA CLAUDIA CAROLA XENO

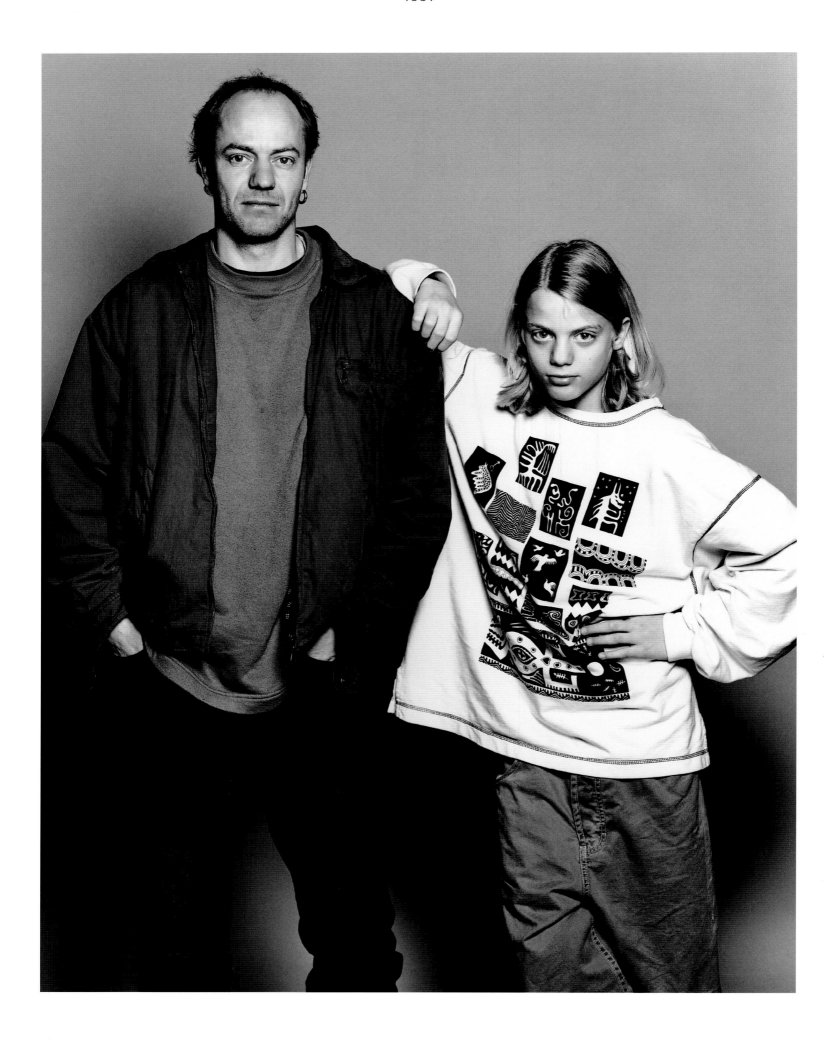

BENI MIRKO

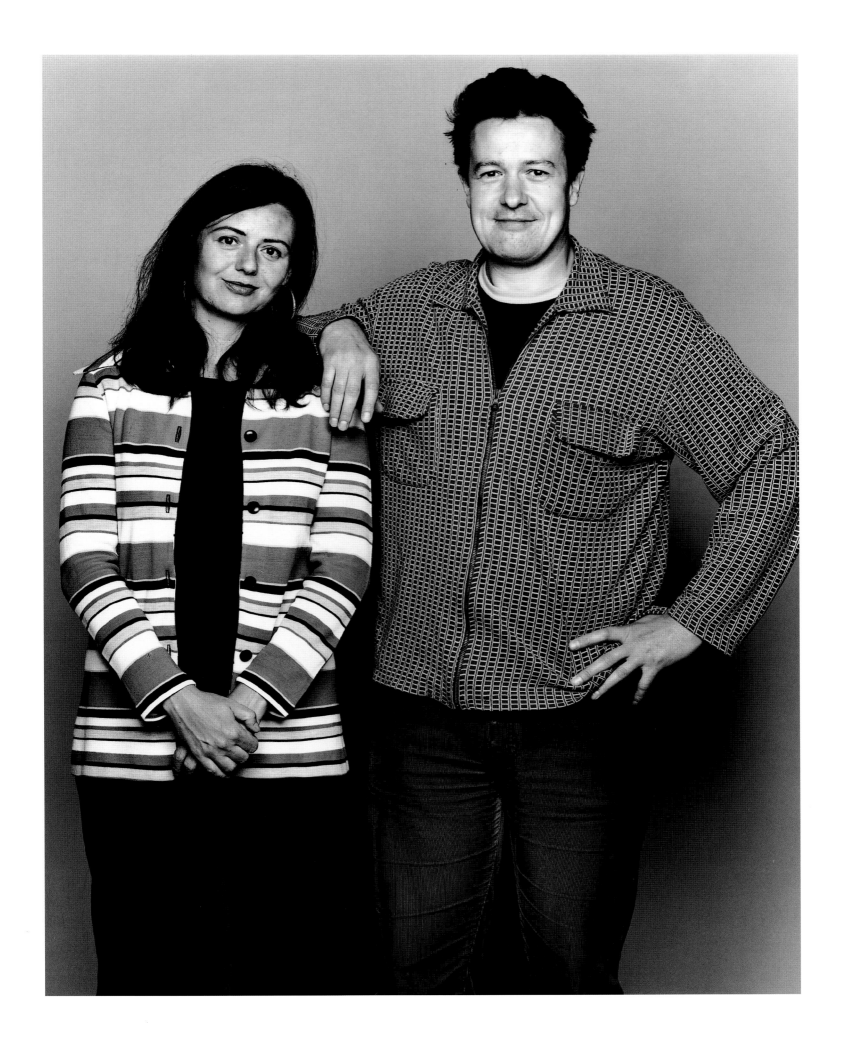

SIBYLLE ANDI

1982

BENI ANDI

1988

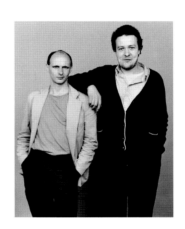

BENI CAROLA HEINI ANDI

1997

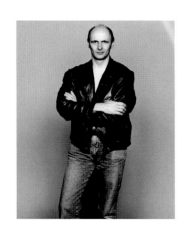

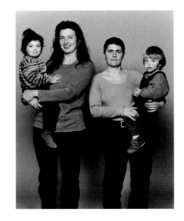

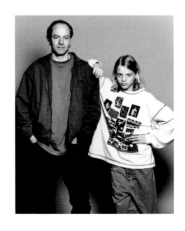

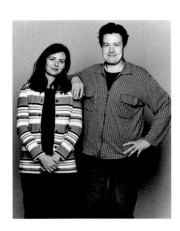

HEINI LUCA CLAUDIA CAROLA XENO BENI MIRKO SYBILLE ANDI

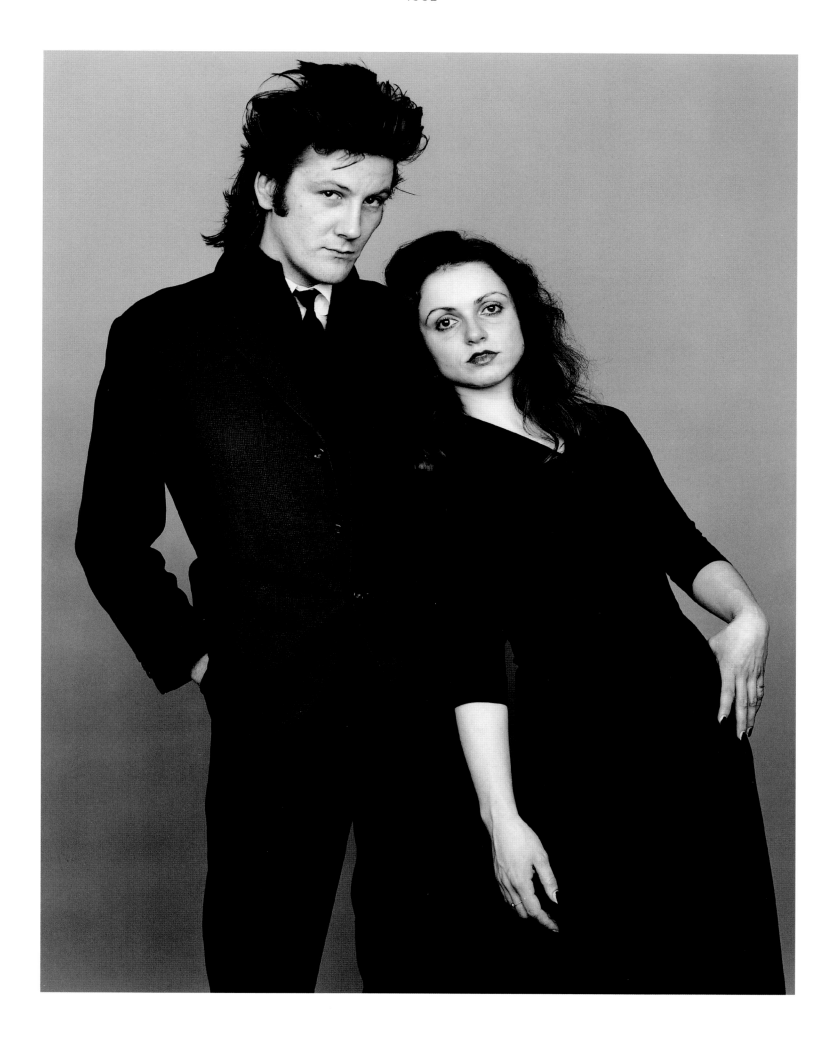

RICO TIZIANA

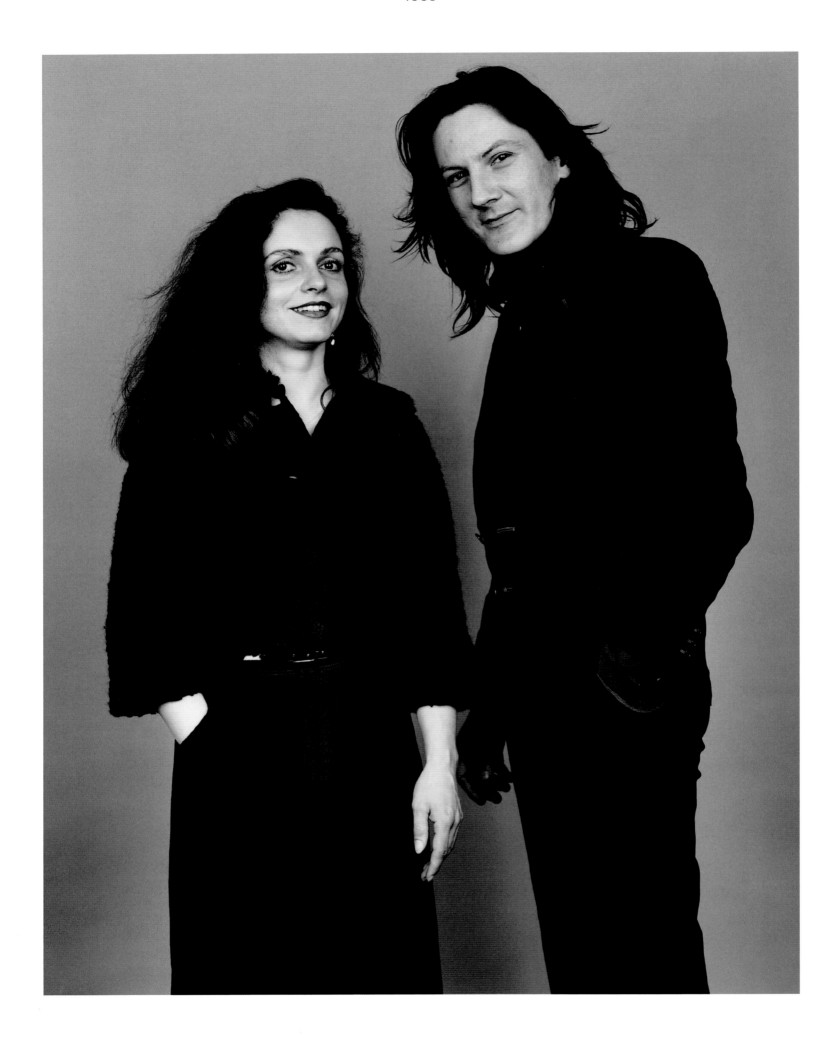

TIZIANA RICO

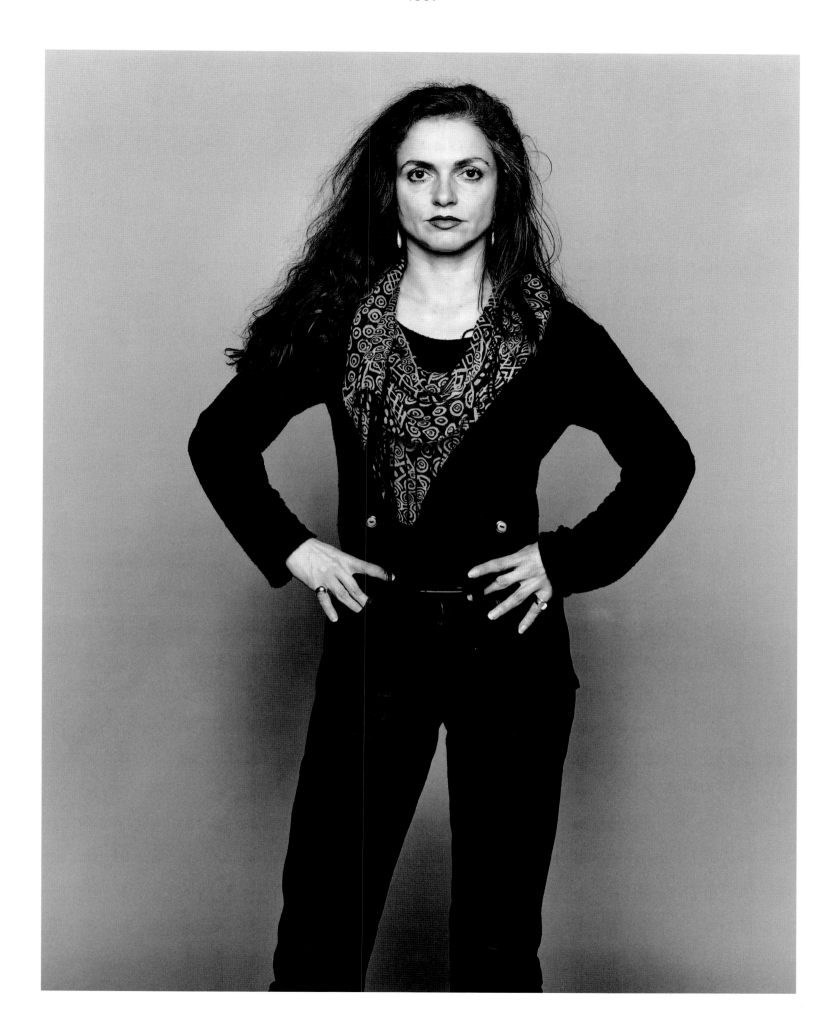

TIZIANA

1982

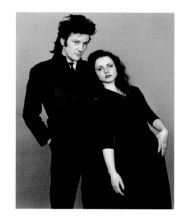

RICO TIZIANA

1988

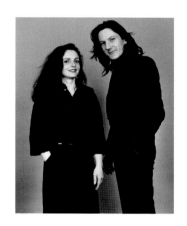

TIZIANA RICO

1997

TIZIANA

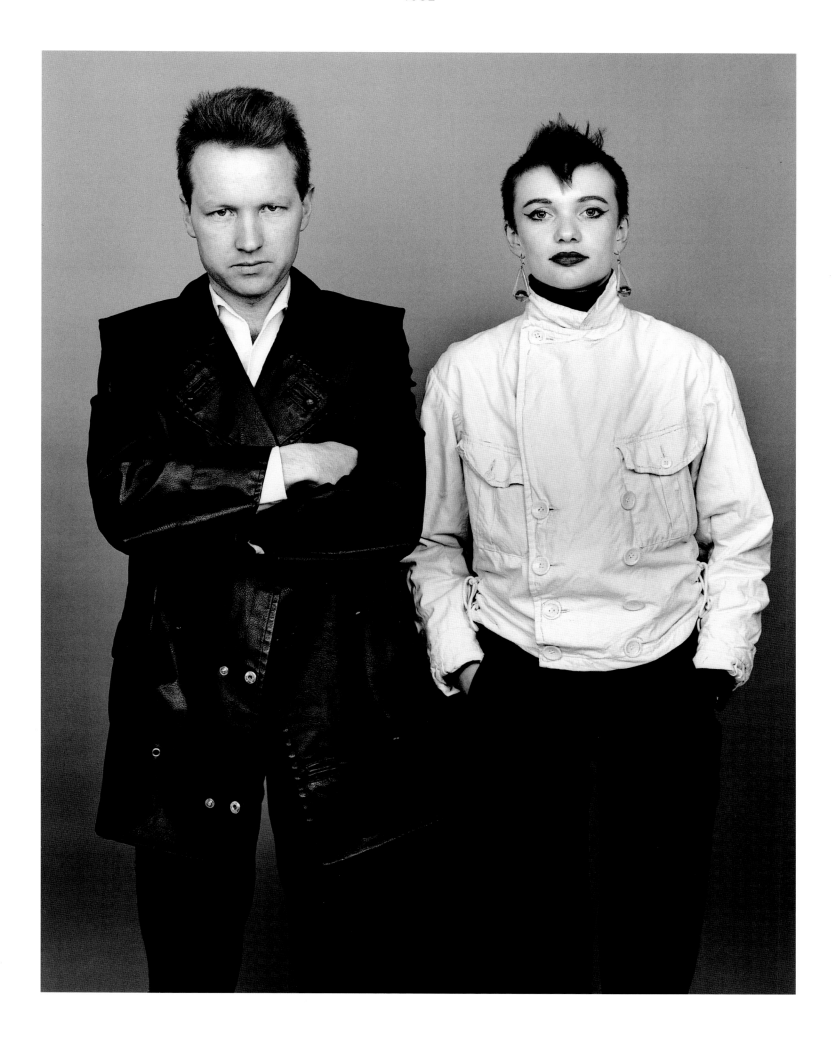

HEINI MICHELINE

1988

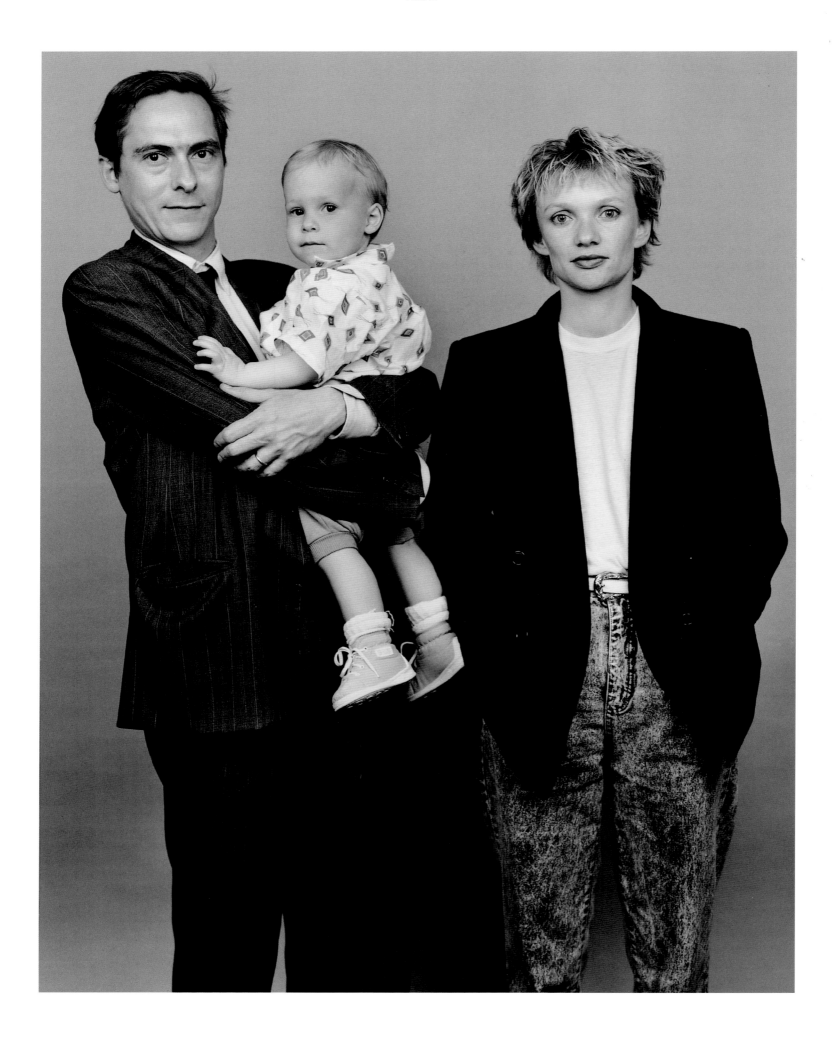

URS SEAN MICHELINE

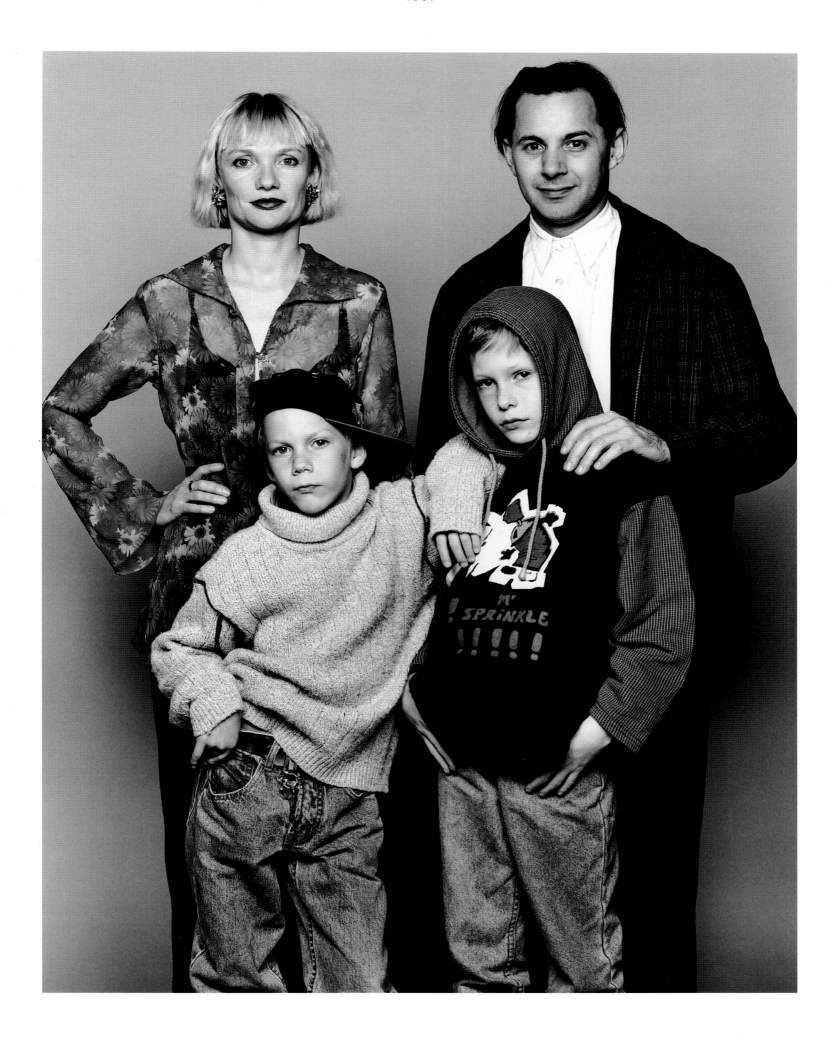

MICHELINE NICOLA SEAN JAN

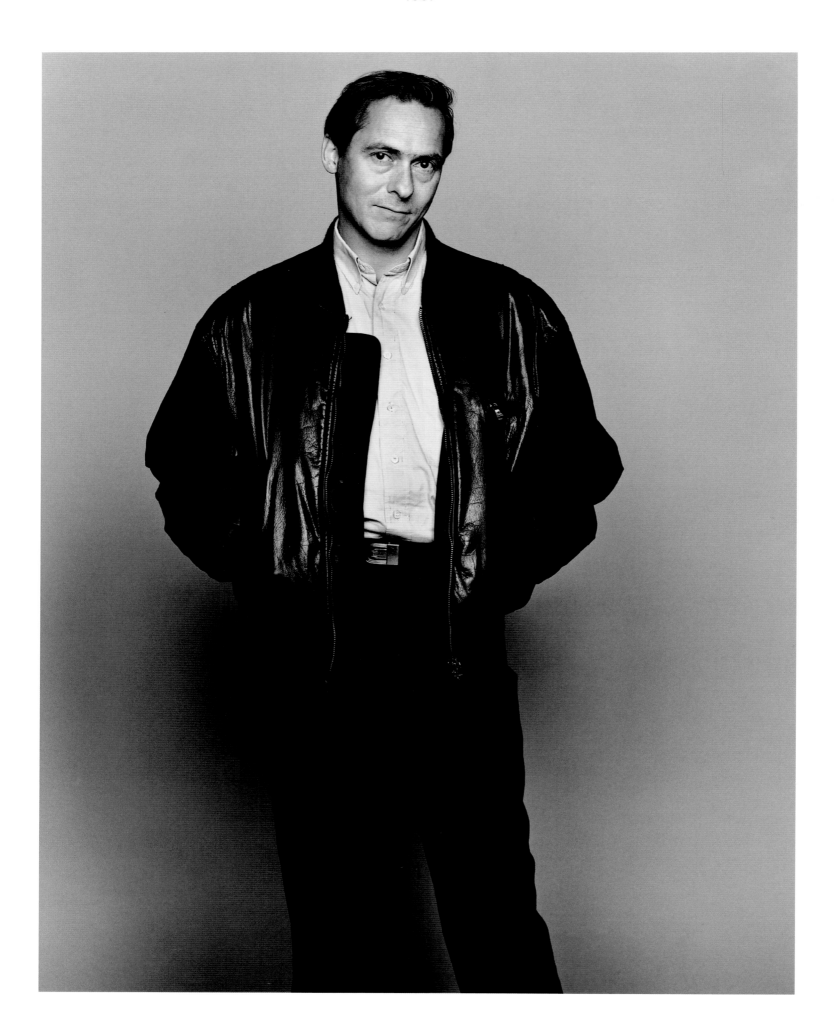

1982

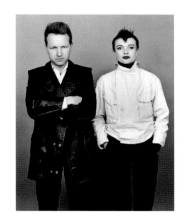

HEINI MICHELINE

1988

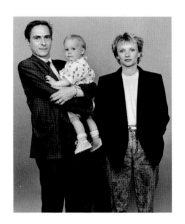

URS SEAN MICHELINE

1997

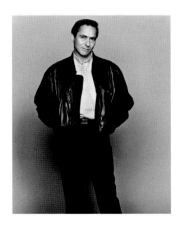

MICHELINE NICOLA SEAN JAN URS

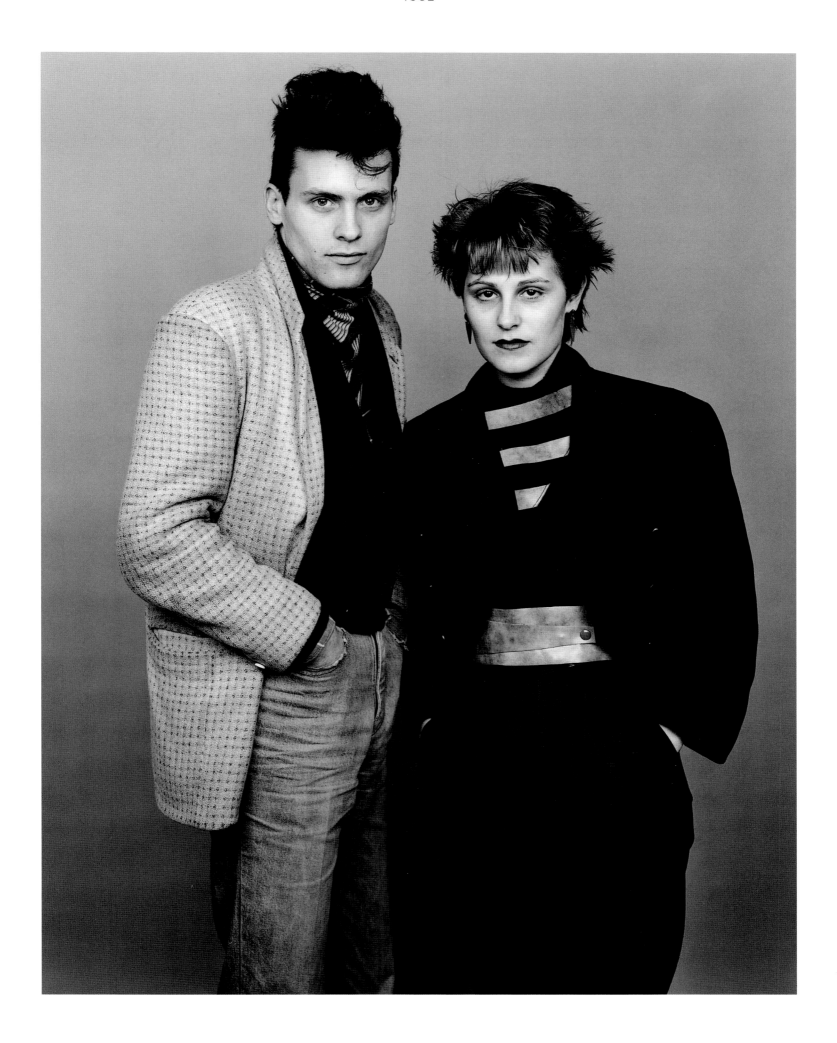

PIETRO　　　　　　　　　　　　　　　　　　　　RUTH

1988

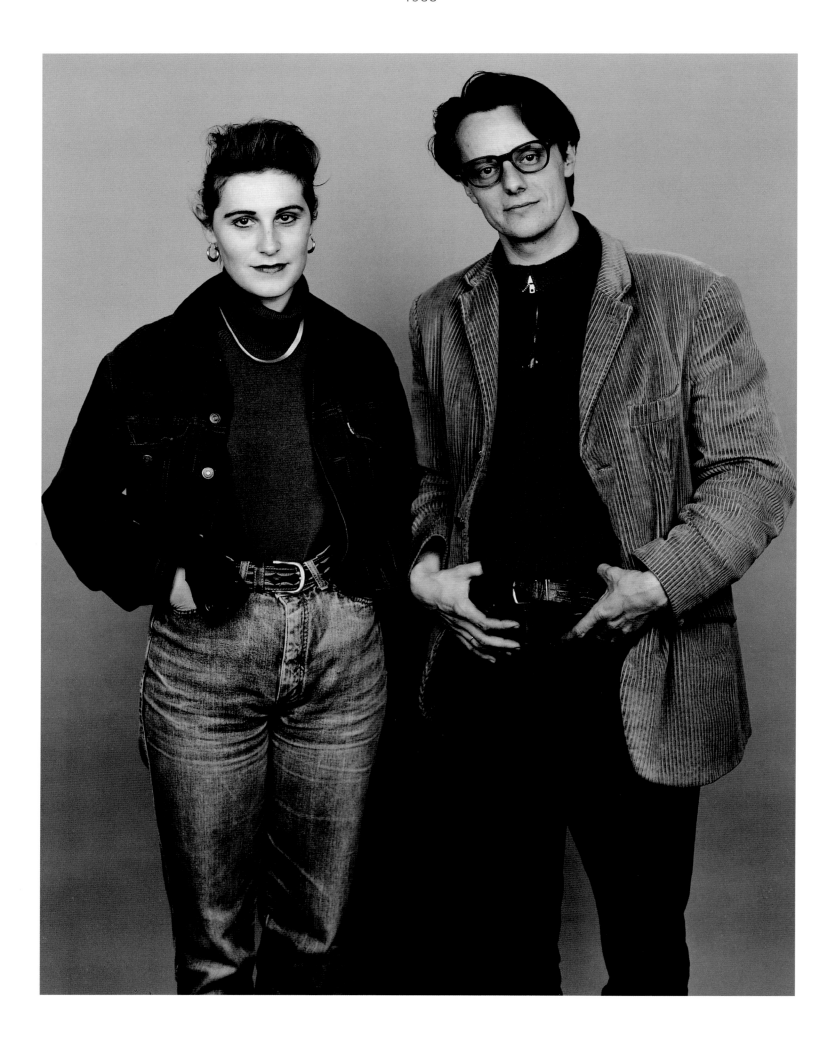

RUTH MARC-ANTOINE

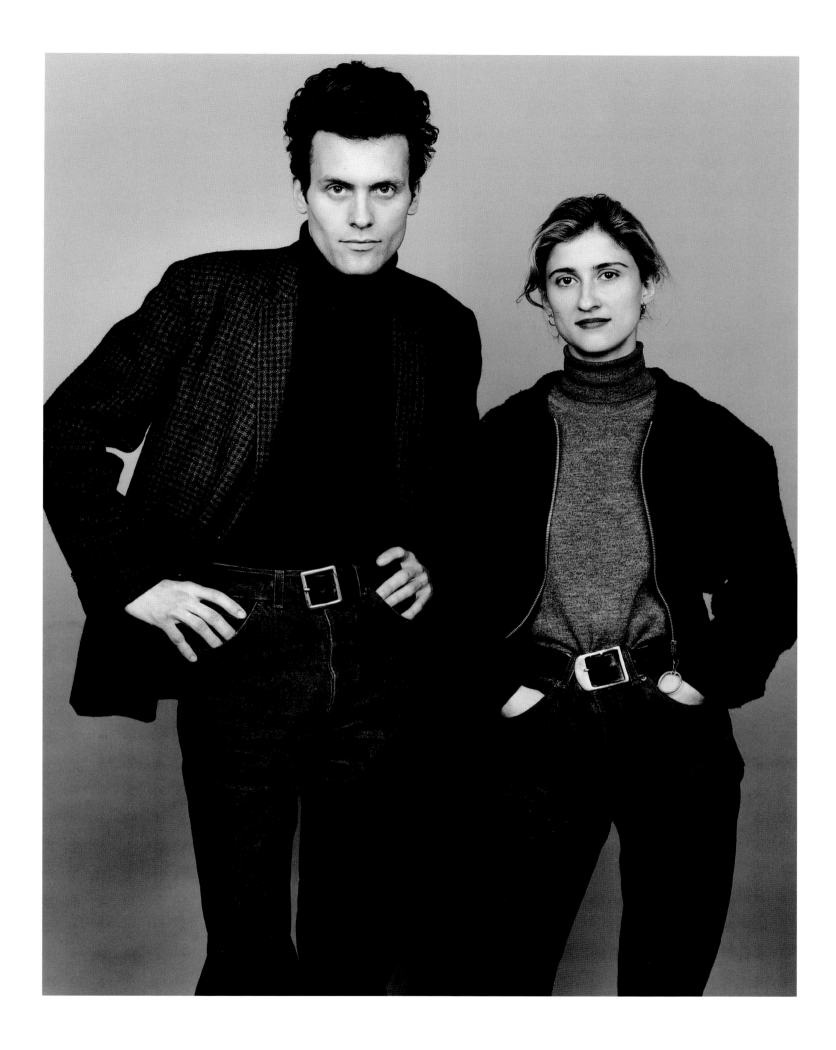

PIETRO ERIKA

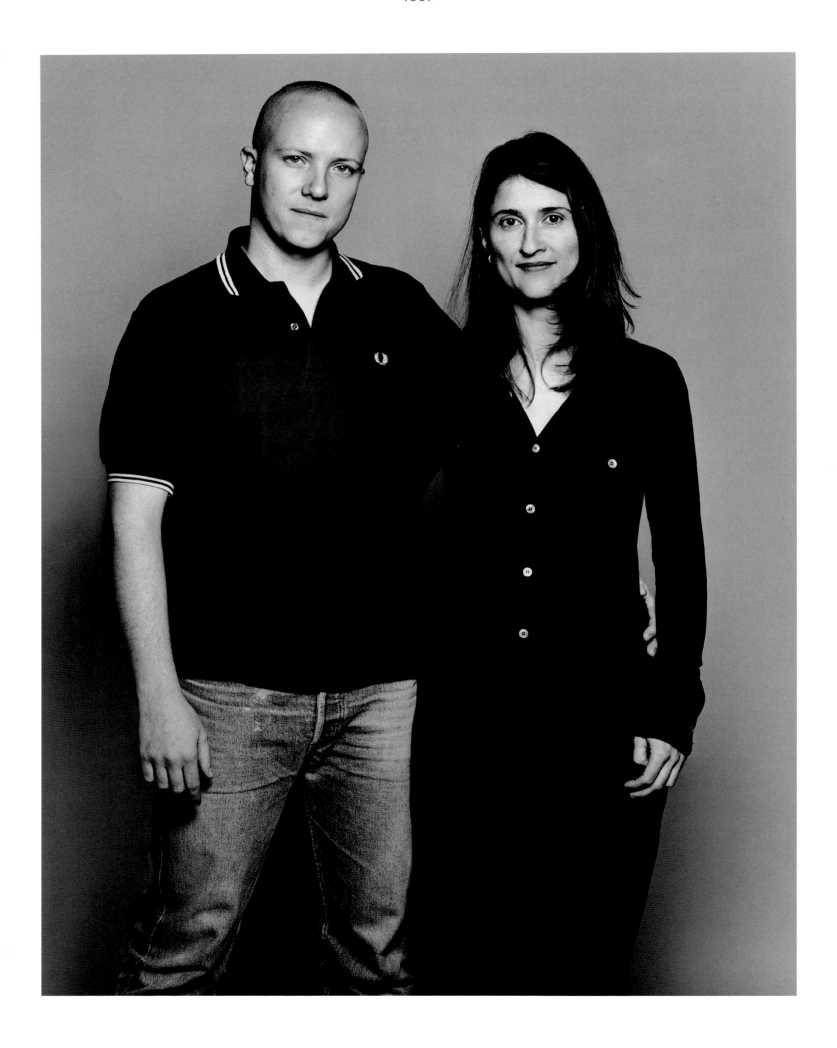

PATRICK ERIKA

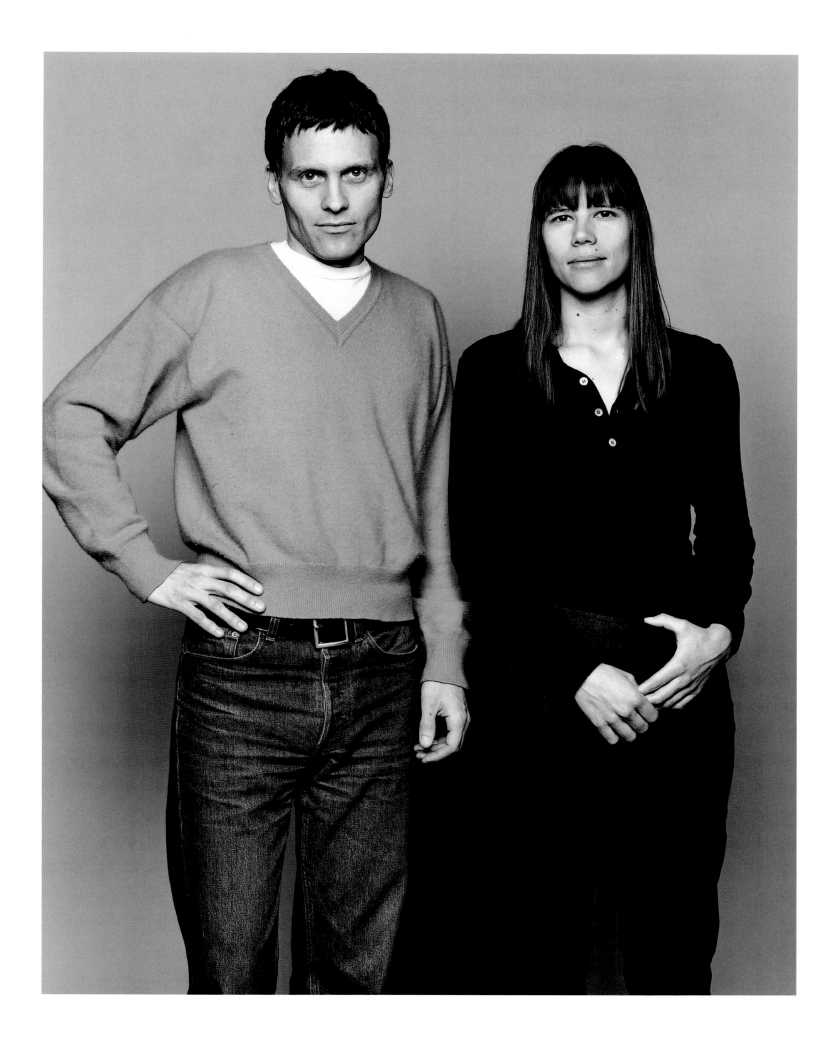

PIETRO ANJA

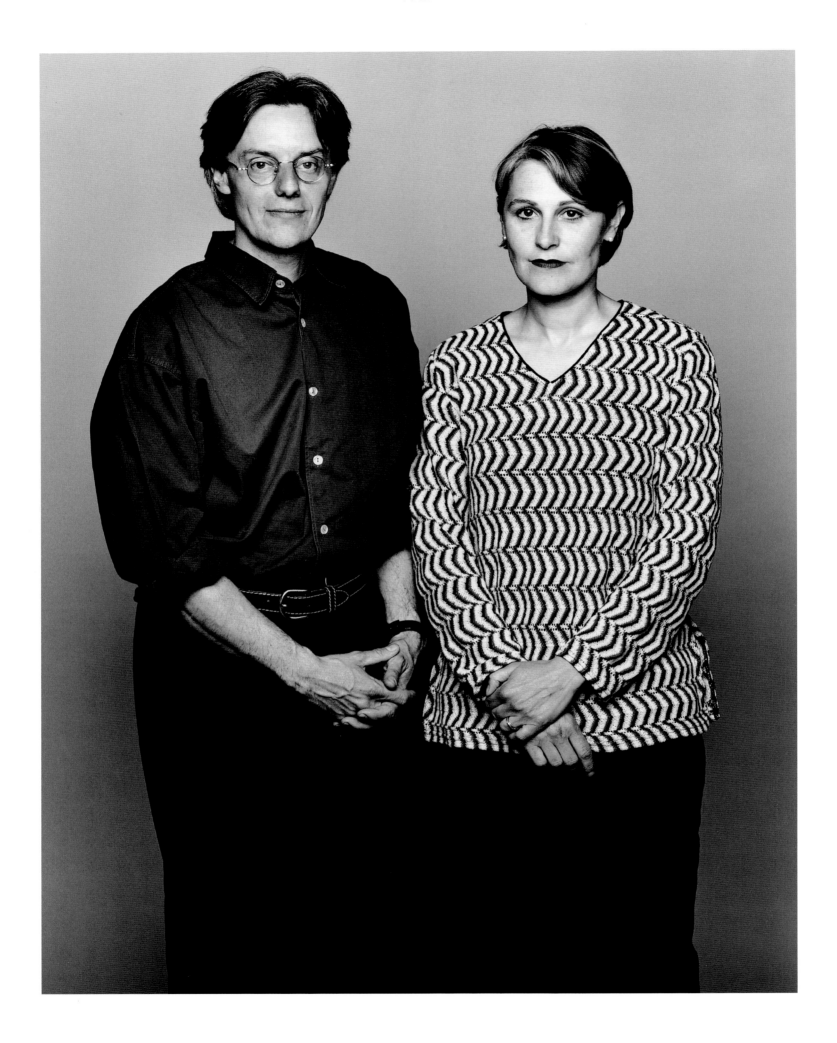

MARC-ANTOINE RUTH

1982

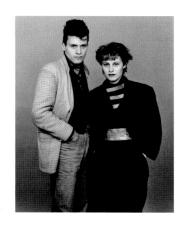

PIETRO RUTH

1988

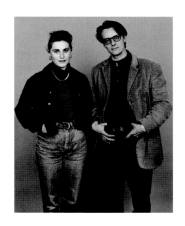

RUTH MARC-ANTOINE

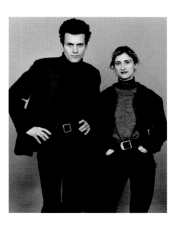

PIETRO ERIKA

1997

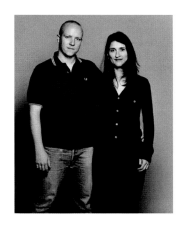

PATRICK ERIKA

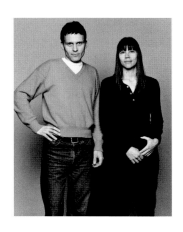

PIETRO ANJA

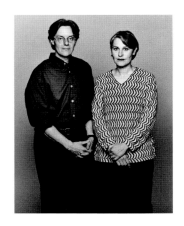

MARC-ANTOINE RUTH

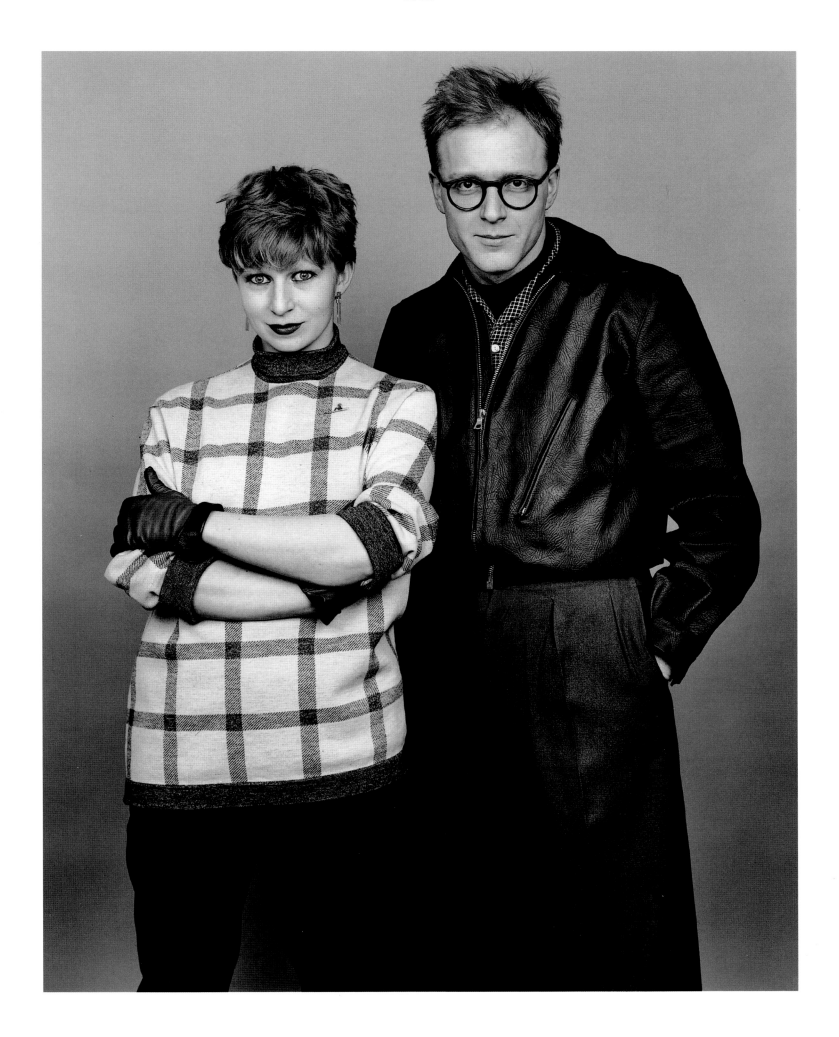

NICOLA KURT

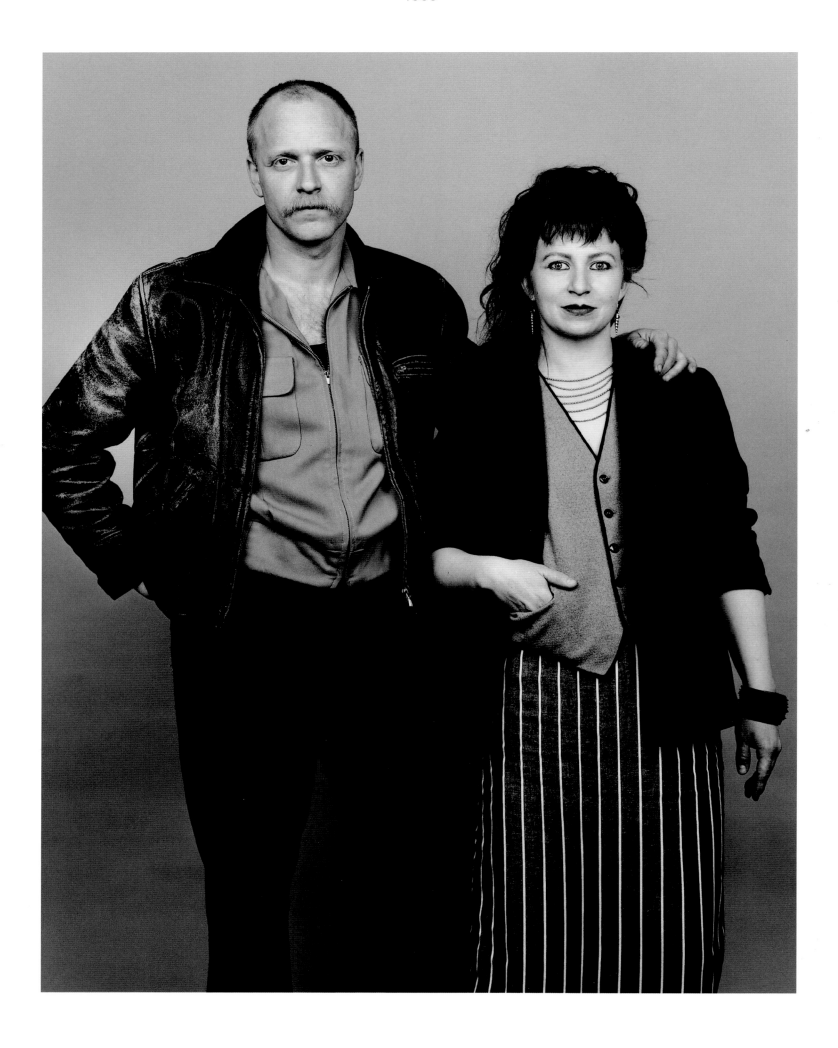

KURT NICOLA

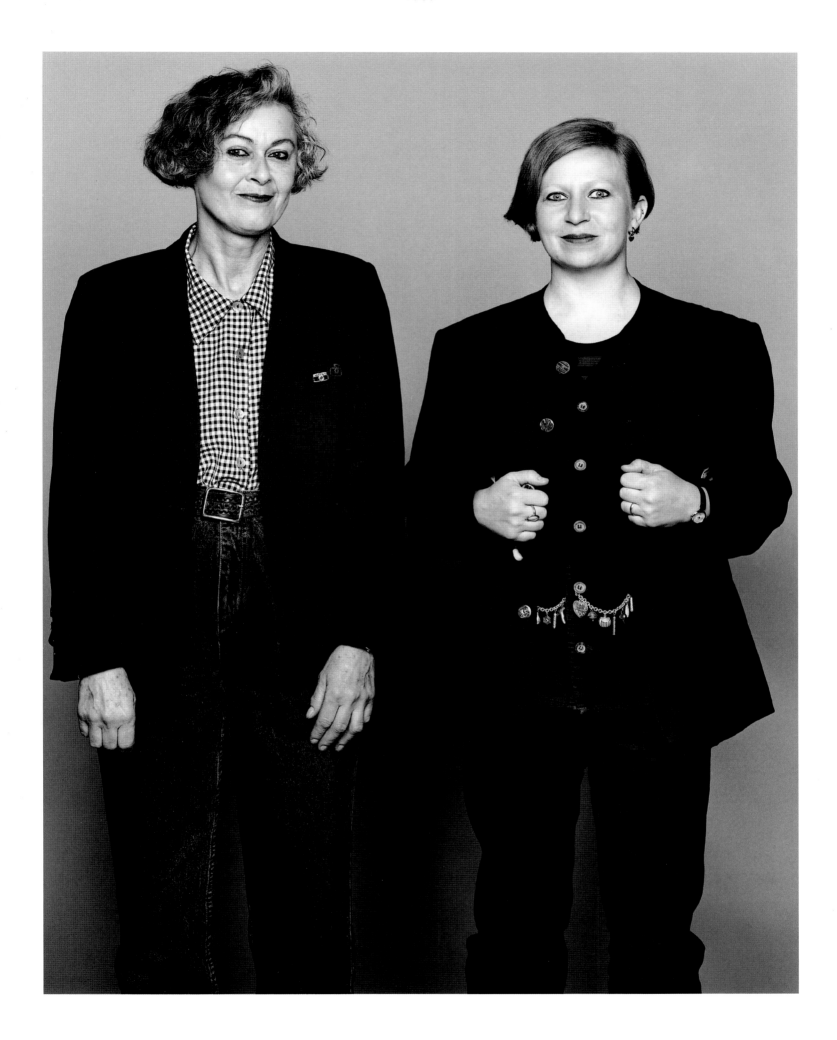

BARBARA NICOLA

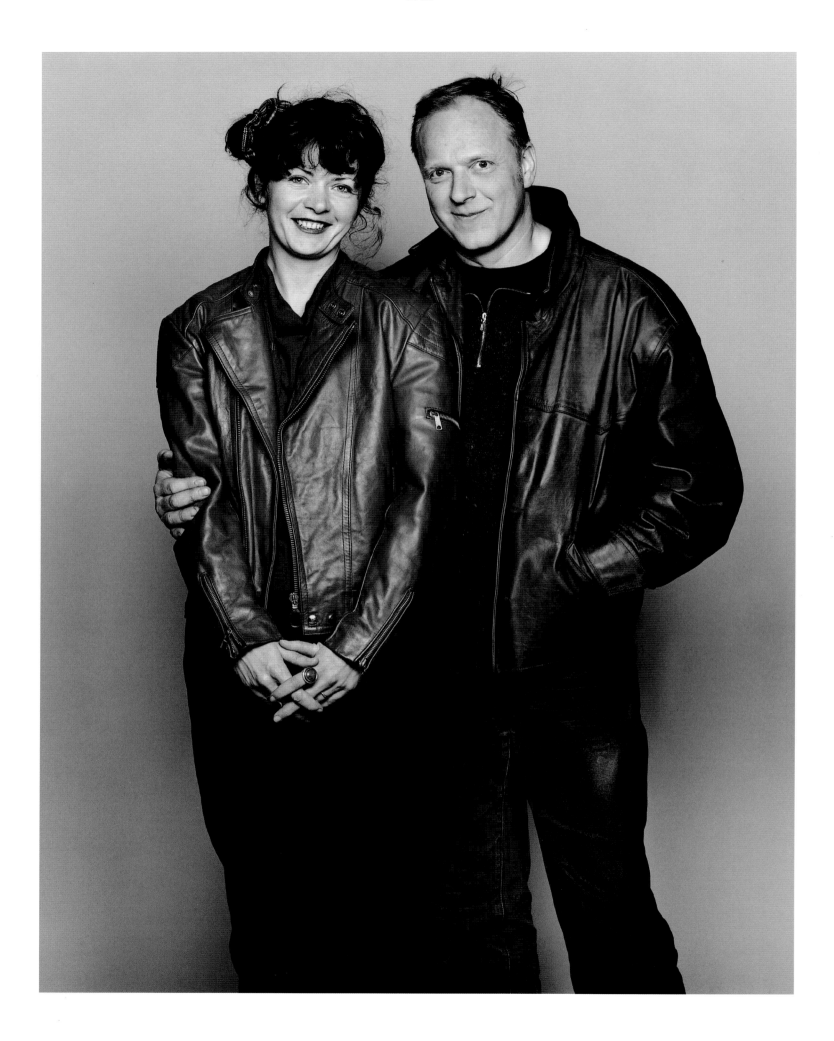

ANNA KURT

1982

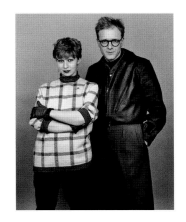

NICOLA KURT

1988

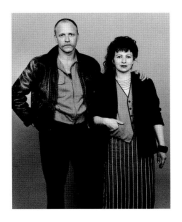

KURT NICOLA

1997

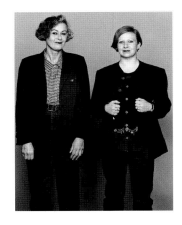

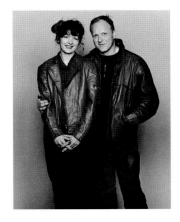

BARBARA NICOLA ANNA KURT

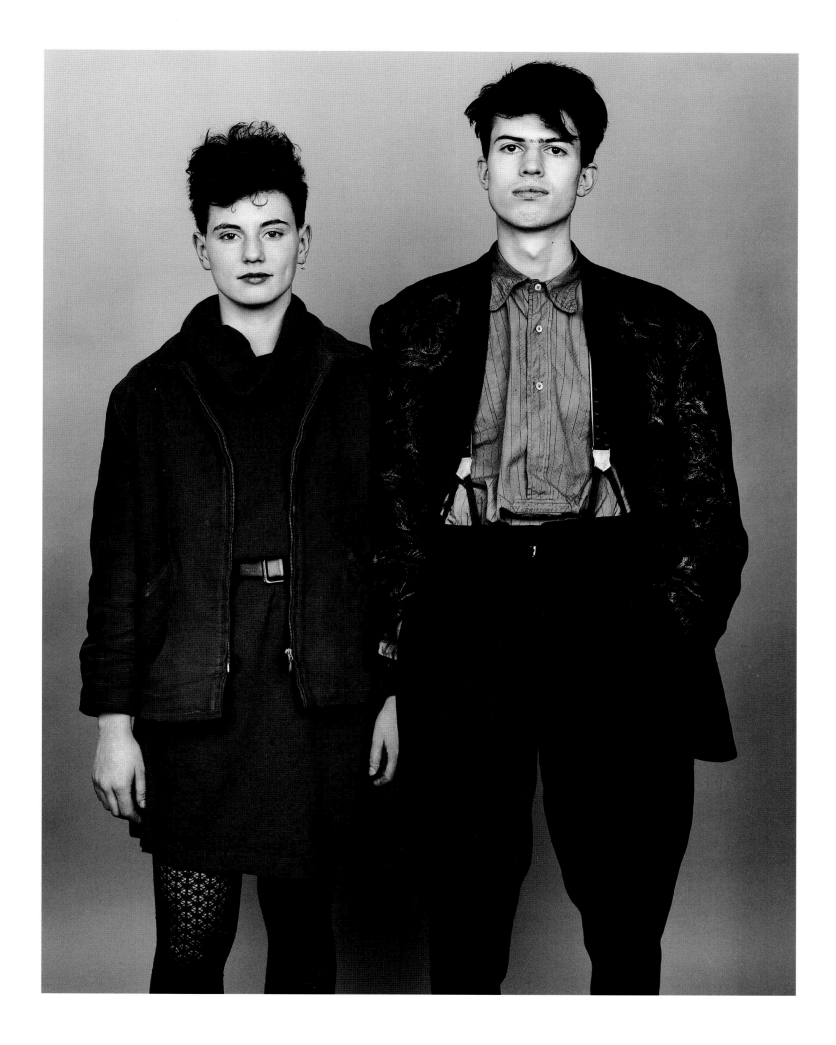

BABS SASCHA

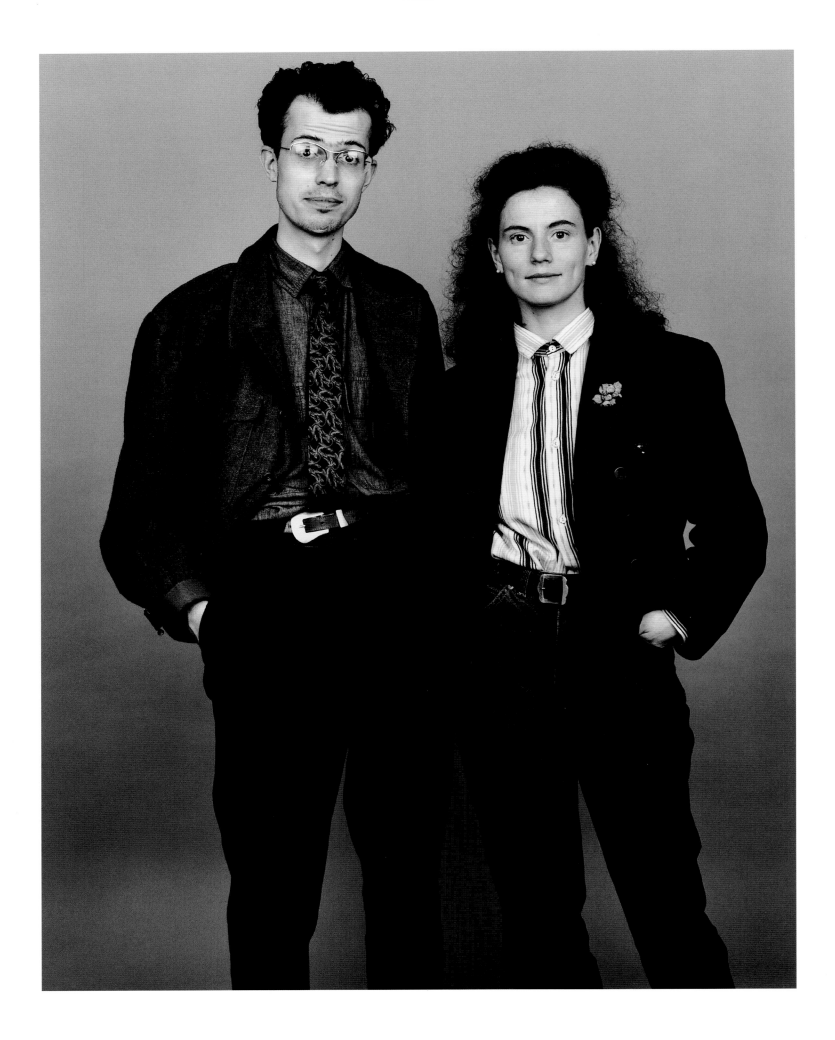

SASCHA BABS

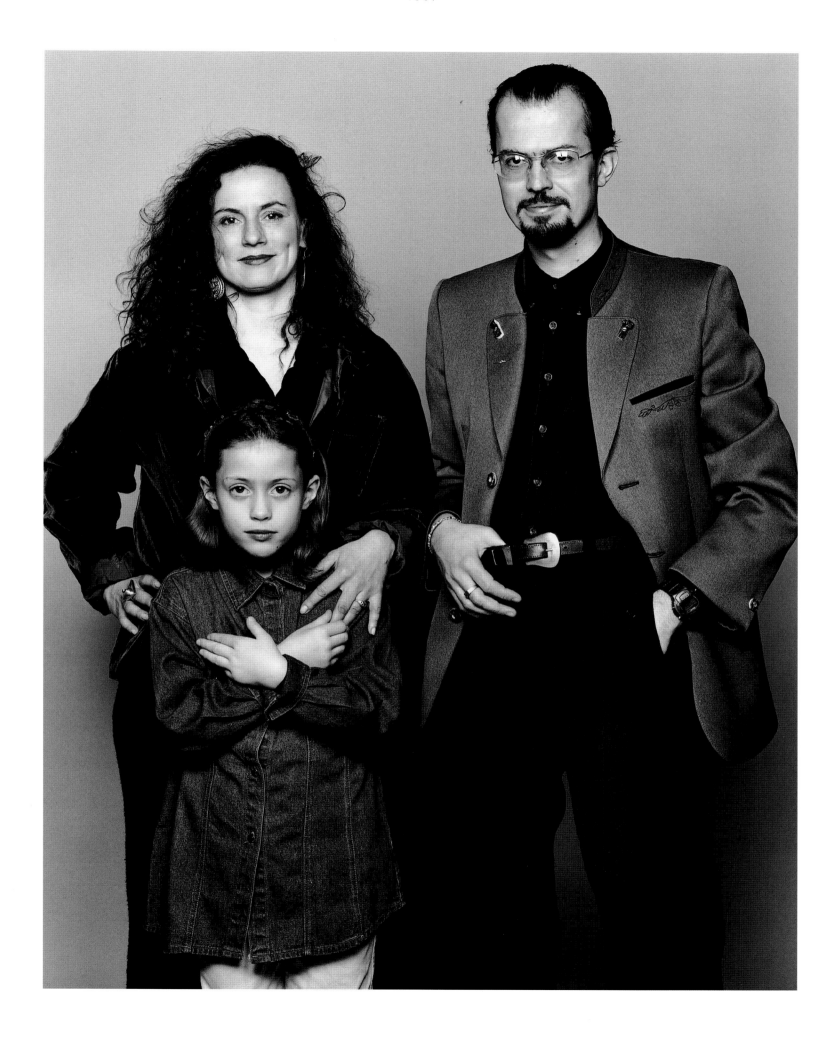

BABS ANNIKO SASCHA

1982

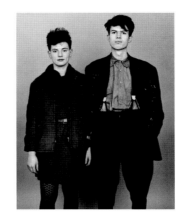

BABS SASCHA

1988

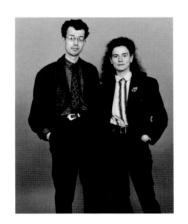

SASCHA BABS

1997

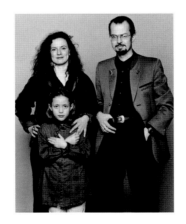

BABS SASCHA ANIKO

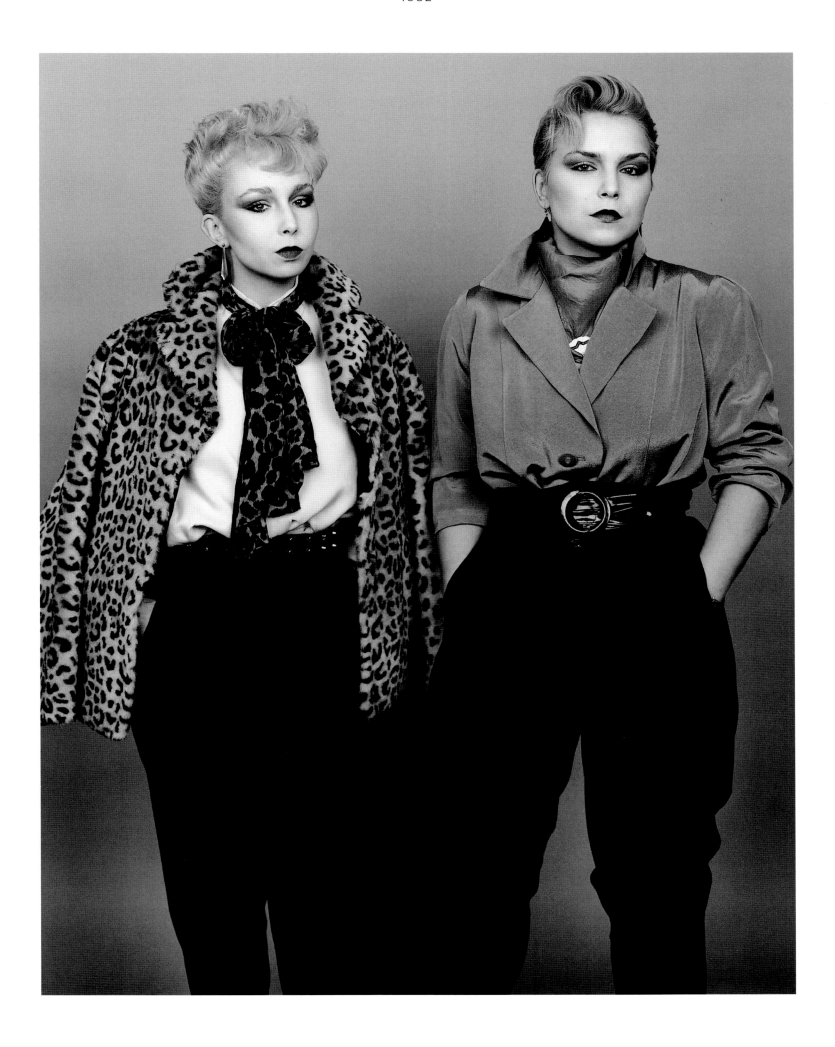

LILI FRANCIS

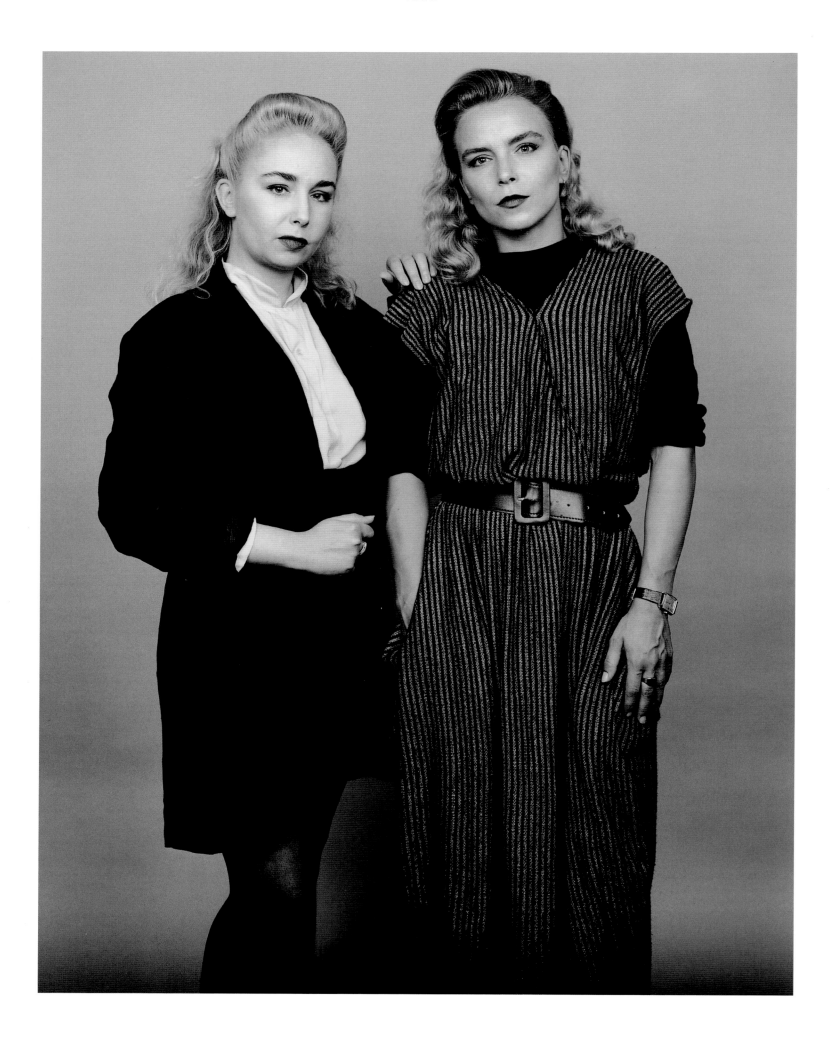

LILI FRANCIS

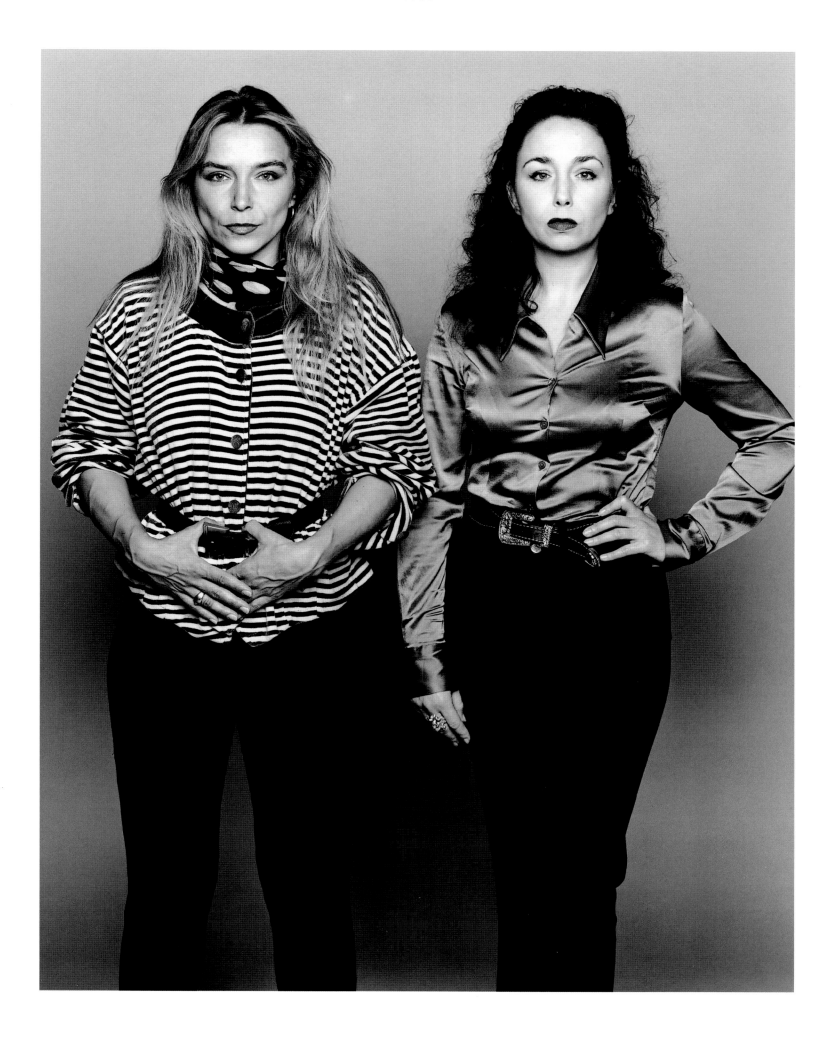

FRANCIS LILI

1982

LILI FRANCIS

1988

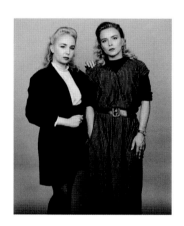

LILI FRANCIS

1997

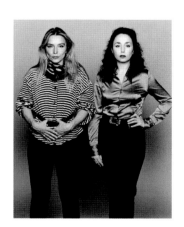

FRANCIS LILI

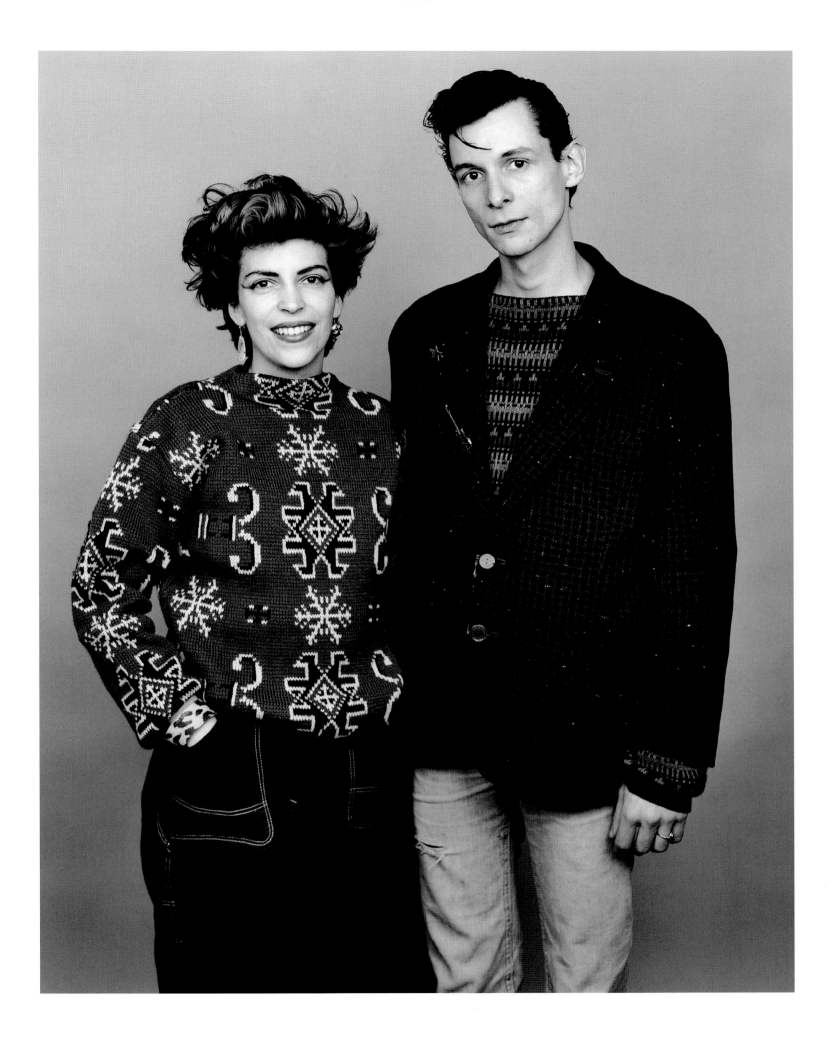

KATJA ENZO

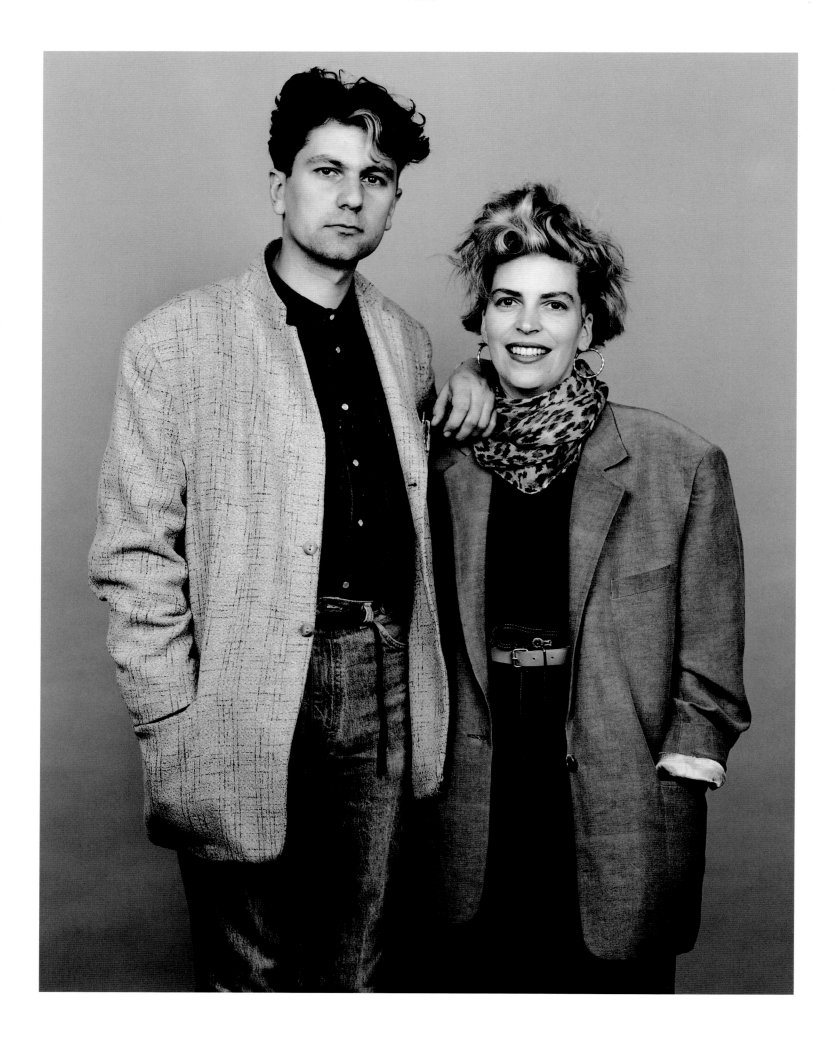

PETER KATJA

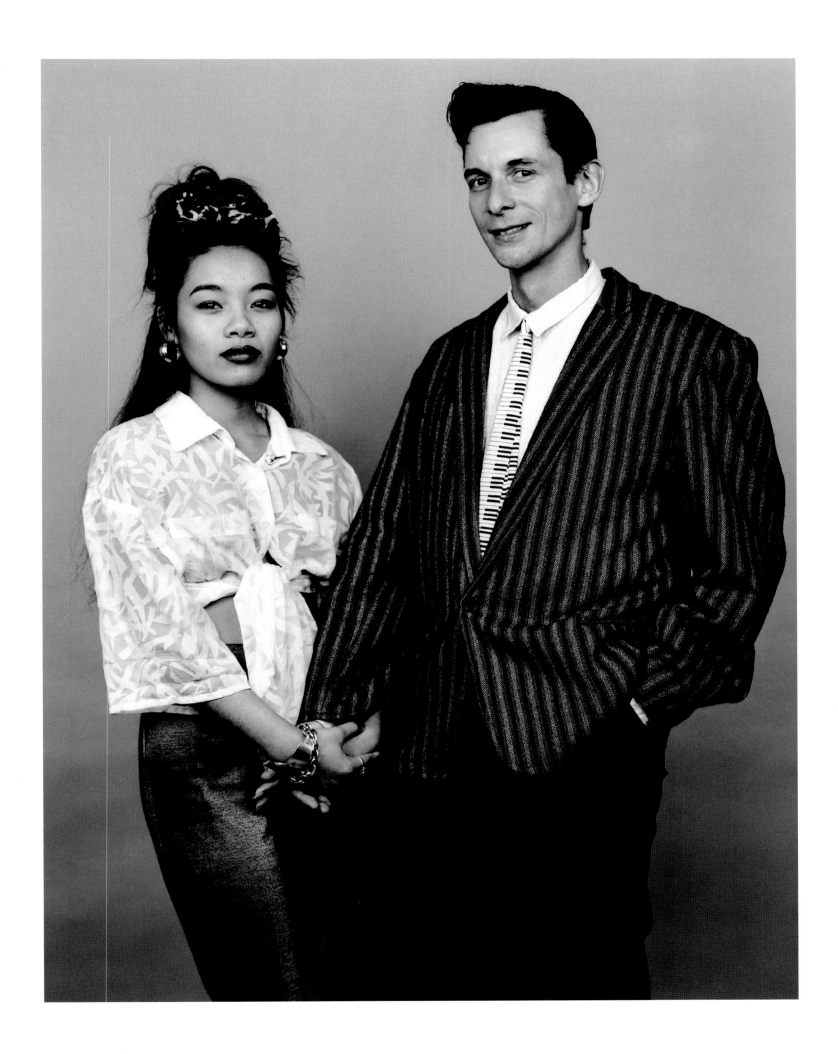

PAMELA ENZO

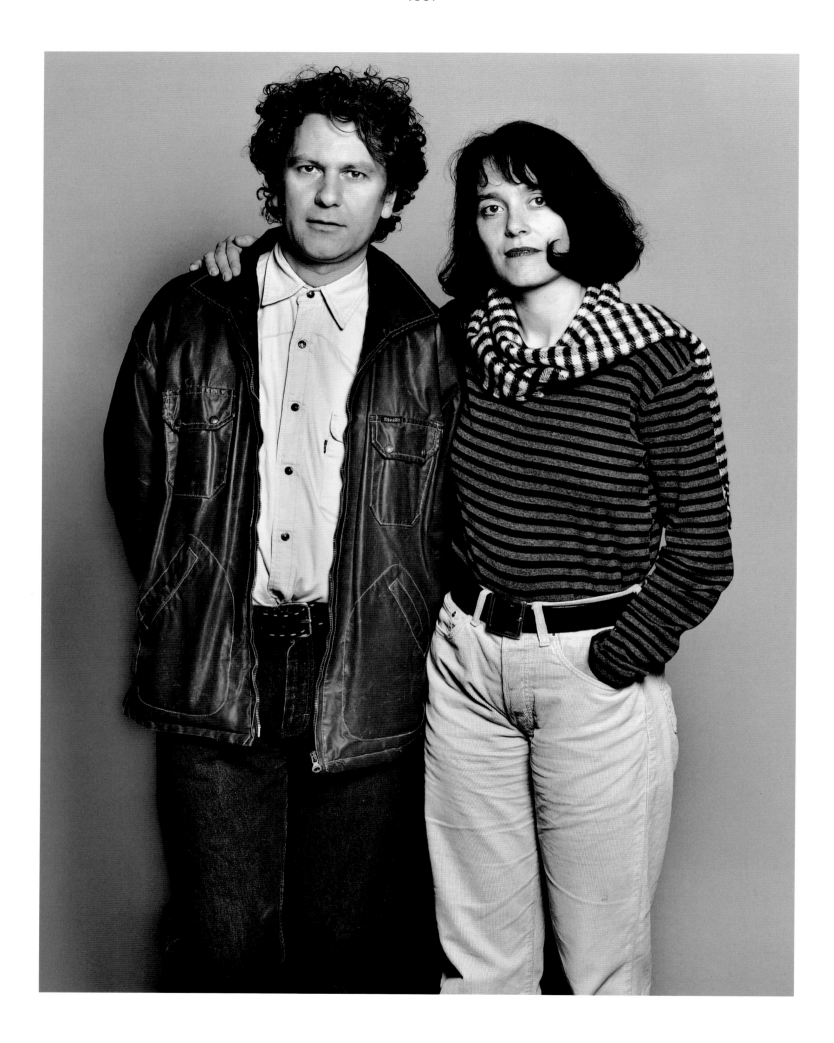

PETER ANITA

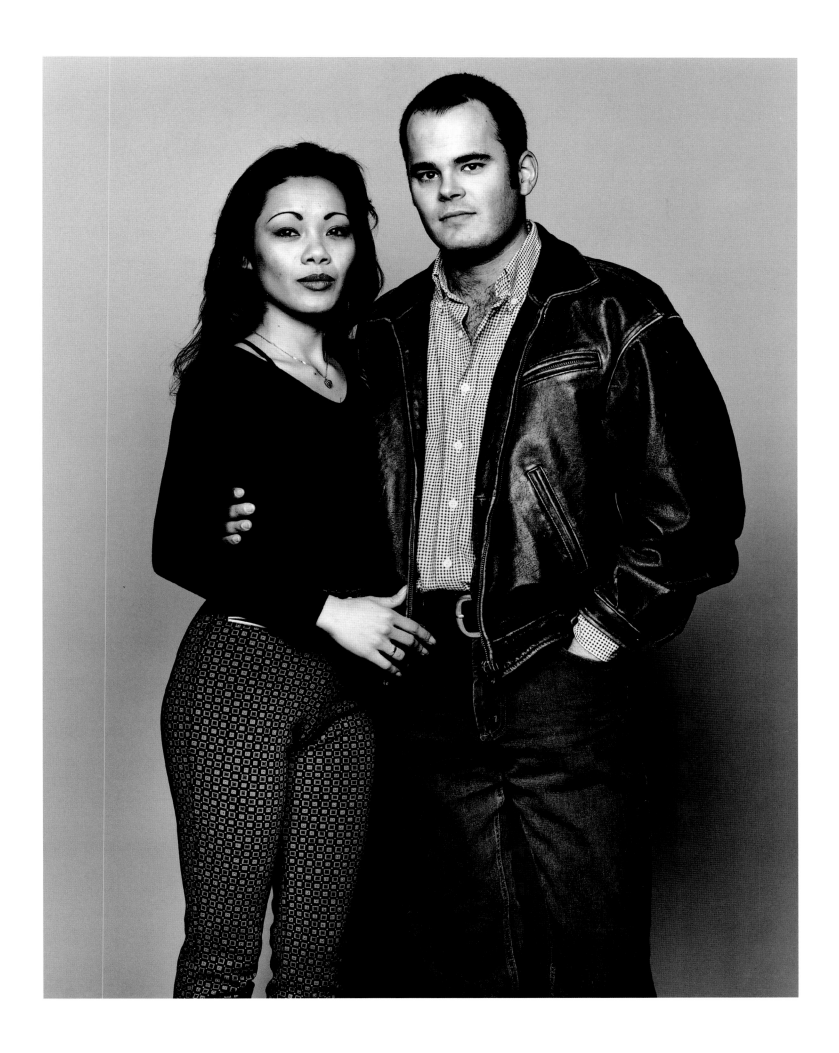

PAMELA PHILIP

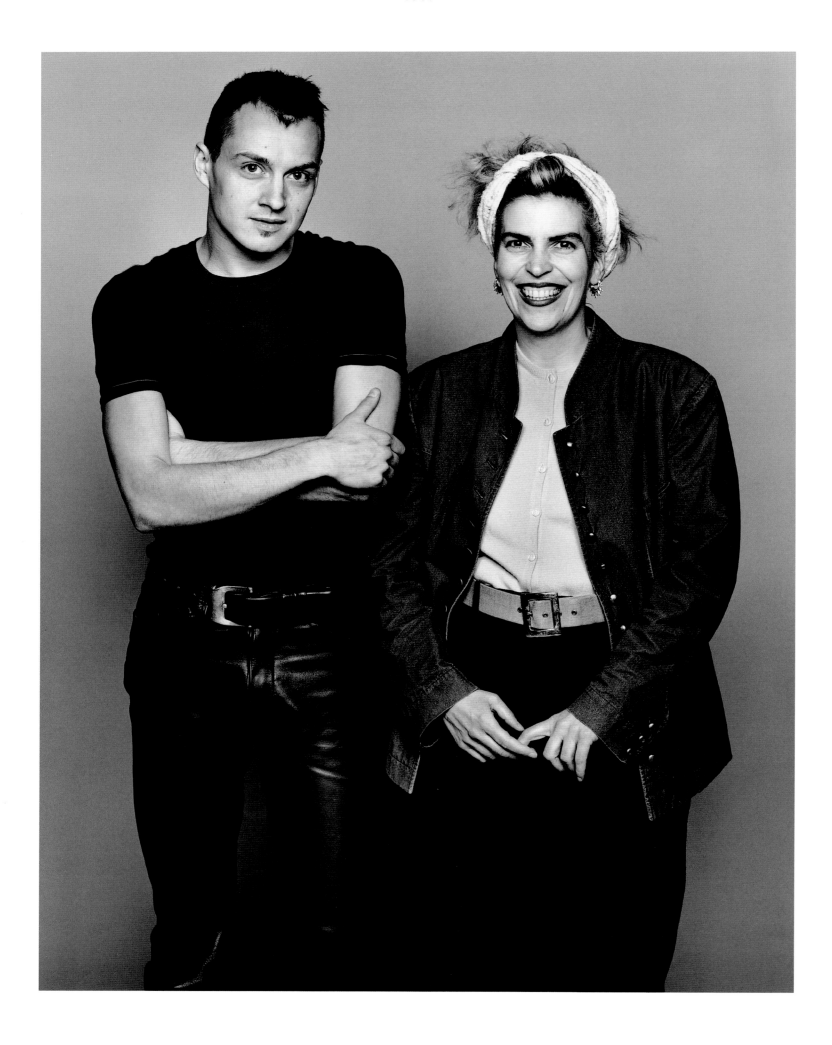

STEFFEN KATJA

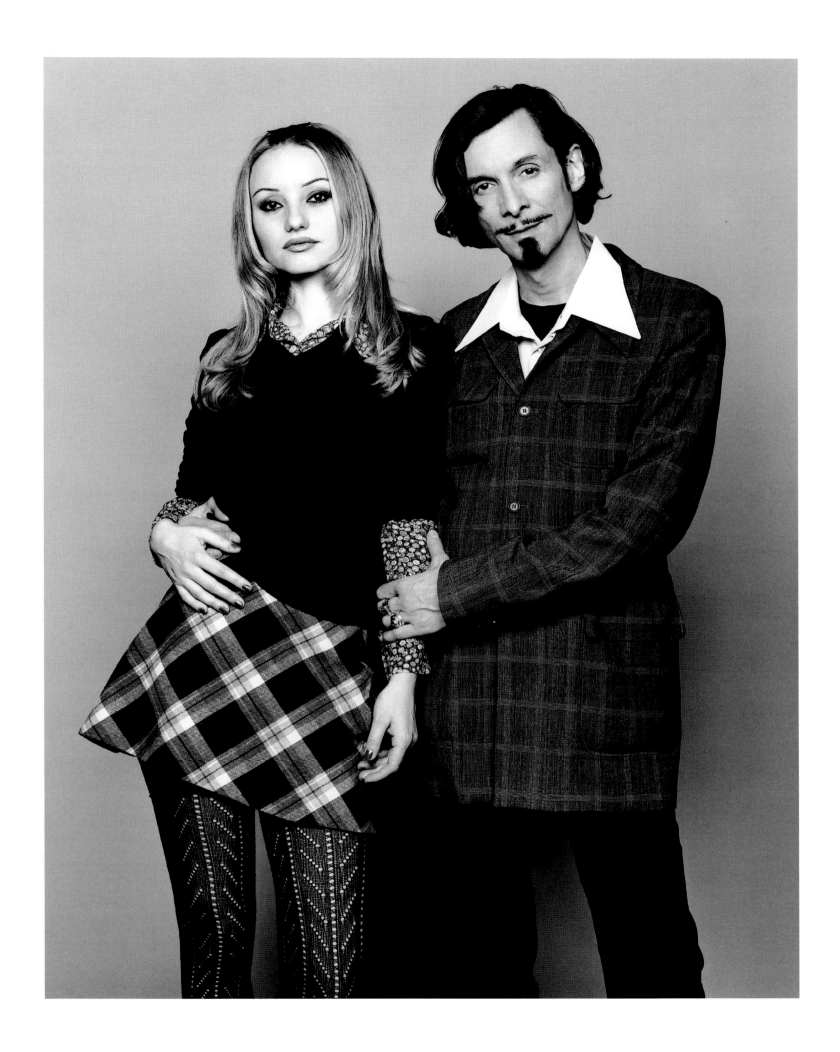

CORNELIA ENZO

1982

KATJA ENZO

1988

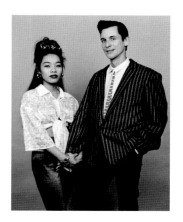

PETER KATJA PAMELA ENZO

1997

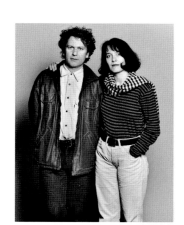
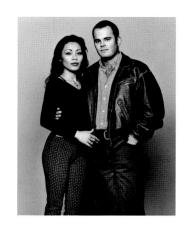
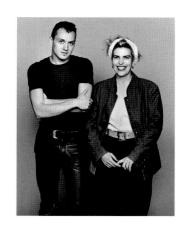
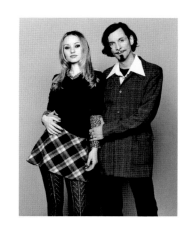

PETER ANITA PAMELA PHILIPP STEFFEN KATJA CORNELIA ENZO

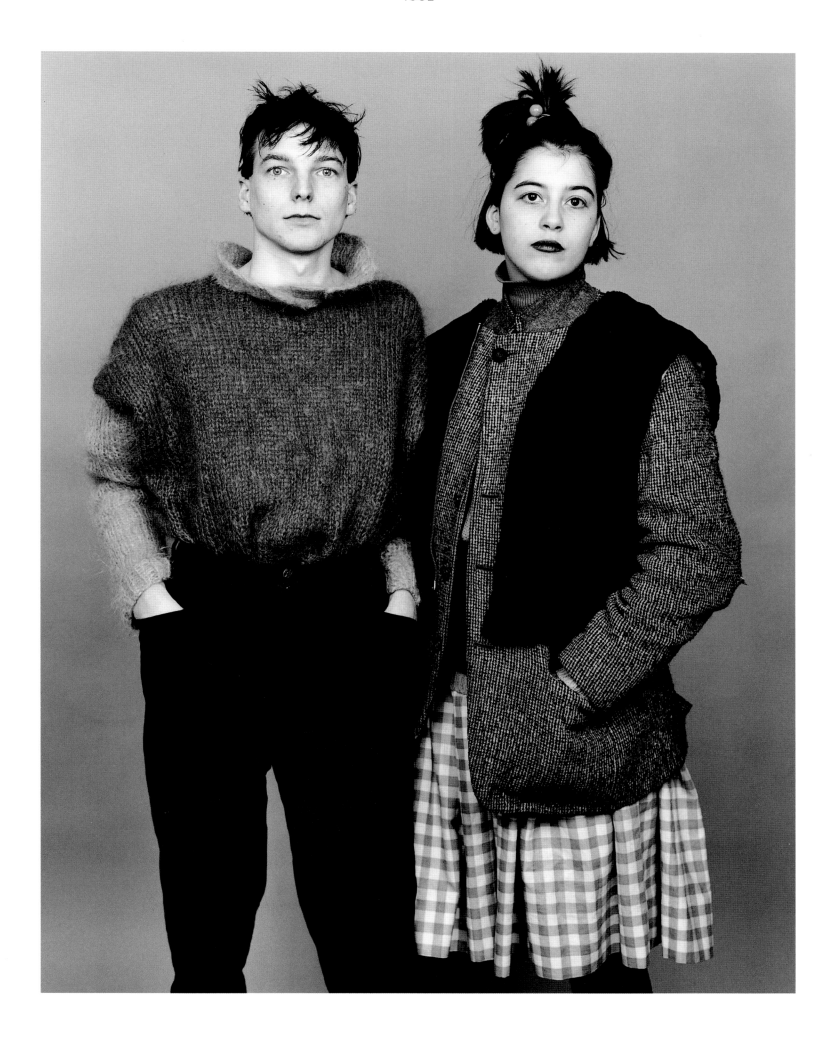

FABIAN REGULA

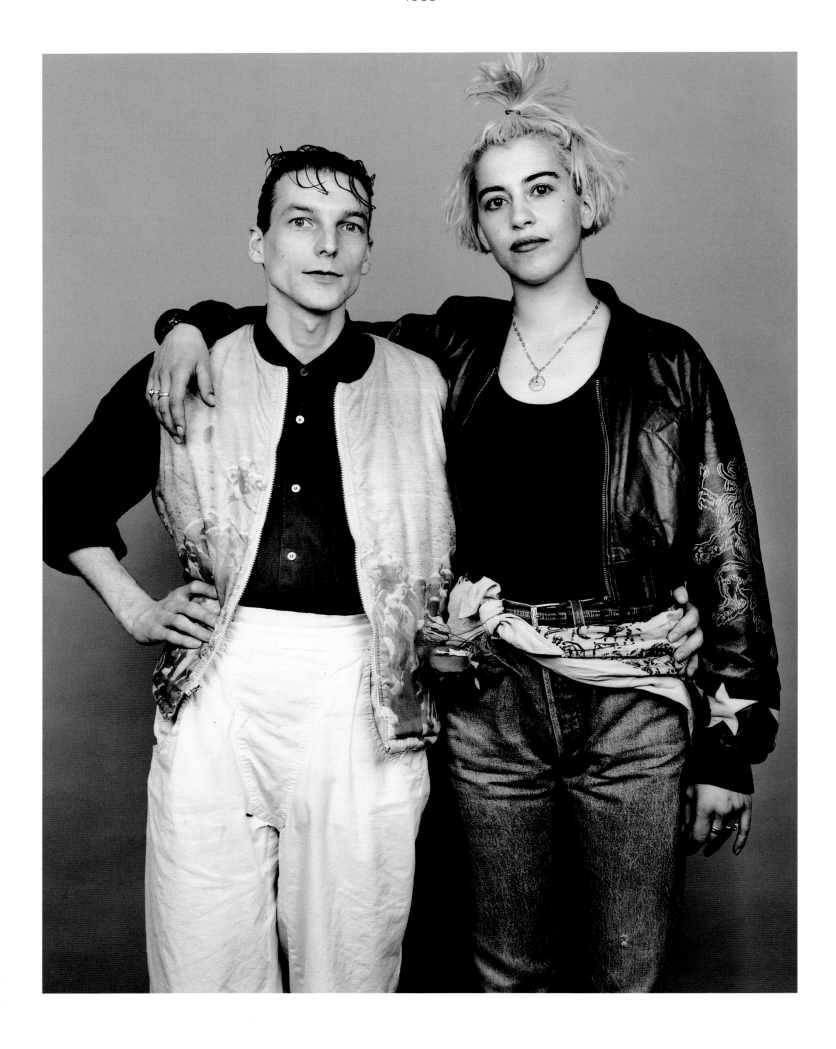

FABIAN REGULA

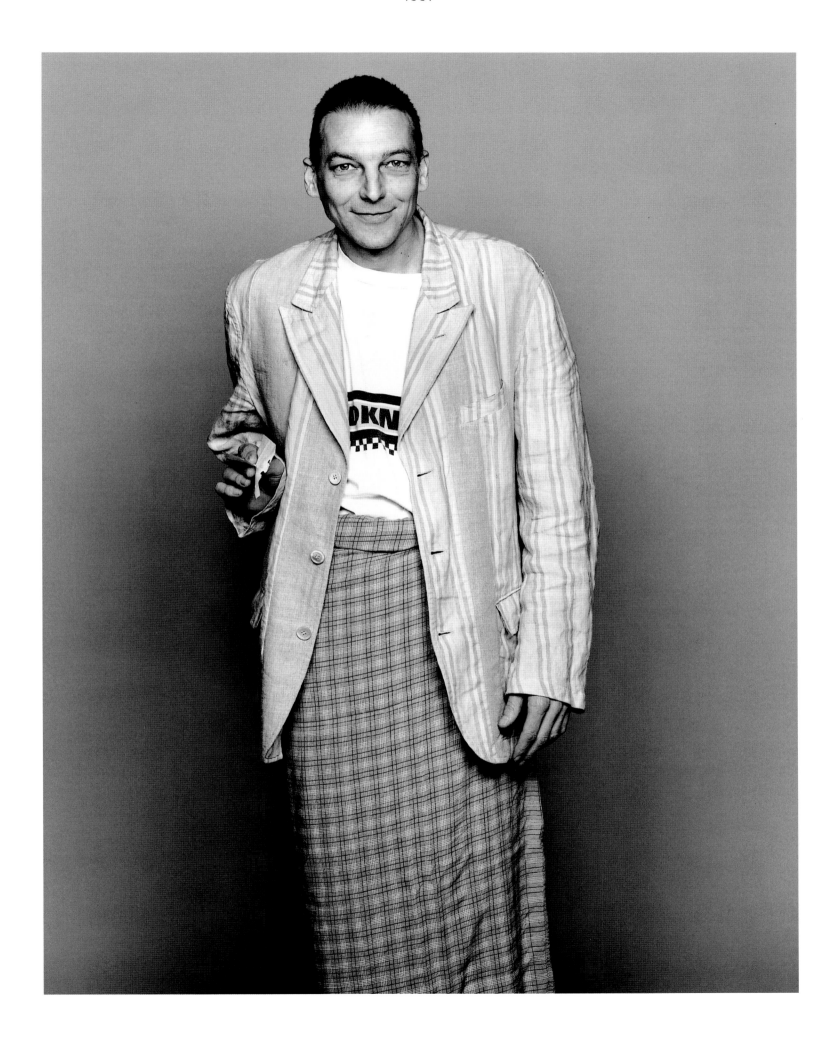

FABIAN

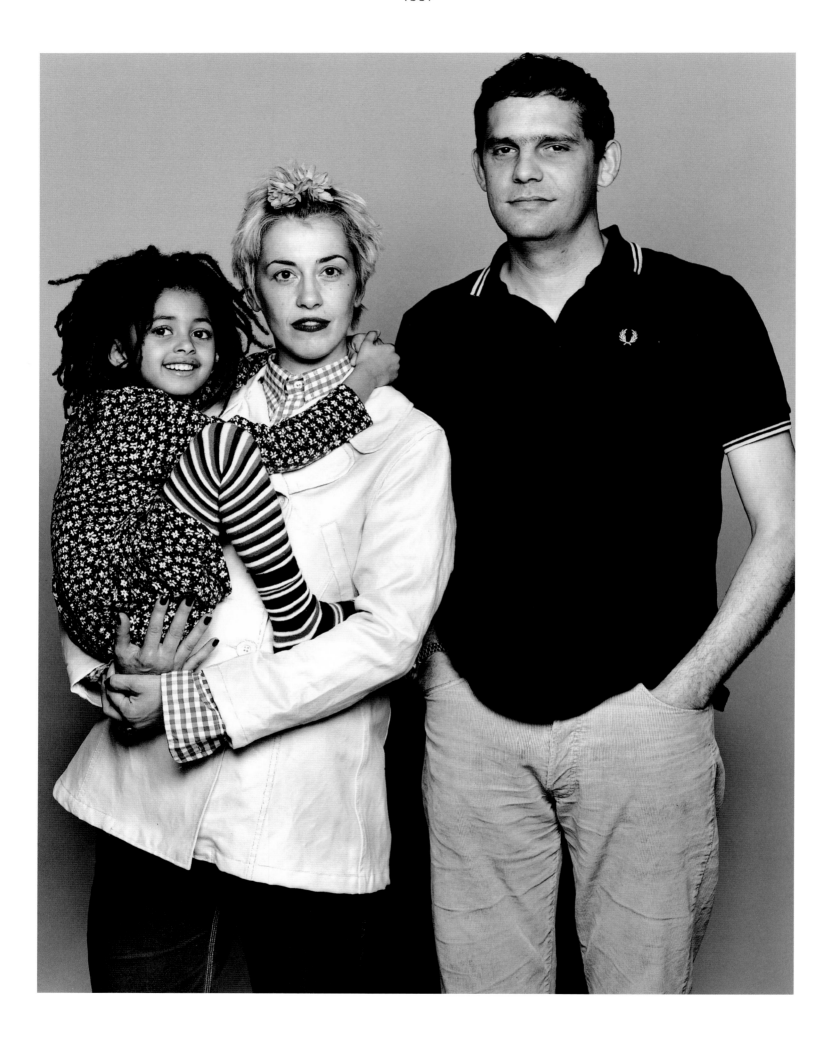

VIMBAI REGULA LUKAS

1982

FABIAN REGULA

1988

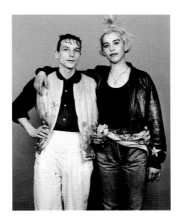

FABIAN REGULA

1997

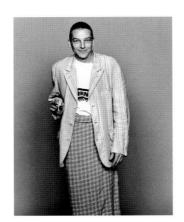 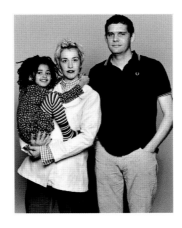

FABIAN VIMBAI REGULA LUKAS

Die Autorinnen

NICOLE MÜLLER

Geboren 1962 in Basel und aufgewachsen im solothurnischen Witterswil. Studium der Romanistik und Russistik in Bochum und Zürich. Von 1986 bis 1991 freie Publizistin in Paris. Denkt und schreibt seit 1992 als Schriftstellerin, Journalistin und Werbetexterin in Zürich. 1996 wurde die Autorin mit dem internationalen Literaturpreis «Crystal Vilenica» geehrt. Publikationen: «L'Ange inconsolable – une biographie d'Annemarie Schwarzenbach» (Lieu Commun, Paris 1989), «Denn das ist das Schreckliche an der Liebe» (Nagel & Kimche, Frauenfeld 1992), «Mehr am 15. September» (Nagel & Kimche, Frauenfeld 1995).

SIGRID PALLMERT

1957 in Luzern geboren und dort aufgewachsen. Studium der Kunstgeschichte, der Klassischen Archäologie und der Volkskunde an der Universität Basel. Seit 1984 Konservatorin für Textilien, Spielzeug, Schmuck und Uhren am Schweizerischen Landesmuseum in Zürich.

Contributors:

NICOLE MÜLLER

Born in Basle in 1962, grew up in Witterswil, Soluthurn. Studied French and Russian in Bochum and Zurich. From 1986 to 1991 free-lance publicist in Paris. Since 1992, thinks and writes fiction, essays, journalism and advertising copy in Zurich. 1996: international prize for literature, "Crystal Vilenica". Publications: "L'Ange inconsolable—une biographie d'Annemarie Schwarzenbach" (Lieu Commun, Paris, 1989), "Denn das ist das Schreckliche an der Liebe" (Nagel & Kimche, Frauenfeld, 1992), "Mehr am 15. September" (Nagel & Kimche, Frauenfeld, 1995).

SIGRID PALLMERT

Born in Lucerne in 1957 and grew up there. Studied art history, classical archaeology and ethnology at the University of Basle. Since 1984 curator specialised in textiles, toys, jewellery and watches at the Swiss National Museum, Zurich.

BARBARA DAVATZ

Geboren 1944 in Zürich. 1948 Umzug der Familie an die Ostküste der USA. Besuch der öffentlichen Schulen. 1962–63 ein Jahr Skidmore College, wo sie allgemeine und gestalterische Fächer wählte. Darauf Rückkehr der Familie in die Schweiz, ins Appenzellische. 1964–65 Vorkurs an der Schule für Gestaltung in Basel, erste fotografische Arbeiten. 1965-68 Fachklasse für Fotografie, Schule für Gestaltung Zürich. 1968 bis heute freiberufliche Tätigkeit, vorwiegend für Zeitschriften, etwas Werbung, Tonbildschauen, Standfotos. Spezialgebiet: Portraits, Portrait-Reportagen. Daneben freie schwarz-weiss-Arbeiten (konzeptuelle Portrait-Serien und Landschaften).

1978/82/84 Bundesstipendien für angewandte Kunst (Fotografie).

Seit 1968 verschiedene Ausstellungen, u.a.: 1976/79/82 Kunstkammer zum Strauhof, Zürich: «Fotografien I/II/III»; 1990 Berner Foto Galerie, Einzelausstellung: «As Time Goes By»; 1992 Institut für moderne Kunst Nürnberg: «Blind. Junge Fotografie aus der Schweiz»; 1994 Fotomuseum Winterthur: «Industrie Bild»; 1996 Museo Cantonale d'Arte, Lugano (im Raum der Schweizerischen Stiftung für die Photographie), Einzelausstellung; 1996 Kunsthaus Zürich: «Kunstlicht»; 1997 Landesmuseum Zürich: «Modedesign Schweiz 1972–1997».

Barbara Davatz lebt seit 1987 zurückgezogen mit Partner, Katzen und Schafen an einem Steilhang auf 860 m.ü.M. im Hügelgebiet des Zürcher Oberlandes. Neben der Fotografie wird, mit zunehmender Leidenschaft, das Kultivieren eigener Gemüse wichtig. 1994 Umzug des Ateliers von Zürich in die alte Weberei im Dorf Steg im Tösstal.

Born in Zurich in 1944. 1948: family moves to the East Coast of the USA. Attends public school. 1962–63: one year of study in the arts and humanities at Skidmore College. Family moves back to Switzerland, to the Canton of Appenzell. 1964–65: foundation course, Basle School of Design, first photographic works. 1965–68: study of photography, Zurich School of Design. 1968 to the present: free-lance work primarily for periodicals, some advertising, slide shows, and stills.
Specialities: portraits, portrait reportage. B/W photography (conceptual portrait series, landscapes).

1978/82/84: Swiss federal stipend for applied art (photography).

Since 1968 various exhibitions, including: "Fotografien I/II/III", Kunstkammer zum Strauhof, Zurich, 1976/79/82; "As Time Goes By", solo exhibition, Berner Foto Galerie, 1990; "Blind. Junge Fotografie aus der Schweiz", Institut für moderne Kunst, Nuremberg, 1992; "Industrie Bild", Fotomuseum, Winterthur, 1994; solo exhibition, Museo Cantonale d'Arte, Lugano (in the space of the Swiss Foundation of Photography), 1996; "Kunstlicht", Kunsthaus, Zurich, 1996; "Modedesign Schweiz 1972–1997", Swiss National Museum, Zurich, 1997.

In 1987 Barbara Davatz settles into a former farmhouse half-hidden on a steep slope in the hills of the Canton of Zurich where she lives with her partner, cats and sheep at an altitude of 860 m. In addition to photography, she has devoted herself with growing passion to cultivating her own vegetables. 1994: moves her studio from Zurich to an old weaving mill in the village of Steg, Tösstal.

Dank

Mein grösster Dank gilt den 44 Erwachsenen und den 7 Kindern, die es mir erlaubten, sie ein- oder mehrmals zu fotografieren, die mir ihr Vertrauen schenkten, die sich (es ist mir sehr bewusst) zum Teil überwinden mussten, um sich wiederholt dem Blick der Kamera zu stellen (dieses Sich-zur-Schau-Stellen das niemand gesucht hat), die mitmachten, aus Solidarität, Freundschaft oder Glauben an das Projekt und die mir auch dann ihre Zeit schenkten, als es galt, in ein abgelegenes Land-Studio zu pilgern.

Sigrid Pallmert danke ich für den entscheidenden Impuls im Jahr 1996, der zur Fortsetzung der Serie führte. Sie hat bei mir sehr viel Energie mobilisiert durch ihre herzliche und enthusiastische Begleitung der neuen 23 Aufnahmen.

Brigitte Stucki danke ich für ihr grossartiges Engagement bei der Buchredaktion, für ihre geduldige und gutgelaunte Beratung.

Iren Monti danke ich für die Auseinandersetzung mit der Arbeit, für den Austausch, für die tragende Freundschaft, jahrein, jahraus.

Patrick Frey danke ich dafür, dass die Fotos aus den Archivschachteln heraus konnten, ans Licht, als Buch.

Walter Keller danke ich für das verlegerische Interesse, das mich zur zweiten Serie im Jahr 1988 motivierte.

Nicola und Kurt danke ich für die zündende Inspiration, von der sie selbst nichts wussten, damals, 1981.

Barbara Davatz

Acknowledgements

My greatest gratitude goes to the 44 adults and 7 children who let me take one or more pictures of them, who entrusted themselves to me, some of whom (I fully realise) were reluctant to face the gaze of the camera again (the kind of self-exposure that no one was looking for), who made a commitment out of solidarity, friendship or faith in the project and who generously gave me their time by making the trek to an out-of-the-way studio.

My thanks go to Sigrid Pallmert for giving me the decisive impulse in 1996 to continue the series. She mobilised a great deal of energy in me through her warmth and enthusiasm during the course of the 23 shooting sessions.

To Brigitte Stucki for her great devotion in editing the book, for her inexhaustible patience and good humour.

To Iren Monti for her involvement in my work, for the fruitful exchange, for her friendship and support, year in and year out.

To Patrick Frey for making it possible to move the photographs from the darkness of their storage boxes into the light of a publication.

To Walter Keller for his interest as a publisher and his encouragement, which motivated me to undertake the second series in 1988.

To Nicola and Kurt for the unwitting spark that initially ignited the project in 1981.

Barbara Davatz

Impressum / Credits

Redaktion / Editing BRIGITTE STUCKI, STEG; BARBARA DAVATZ, STEG
Design HANNA KOLLER, ZÜRICH
Übersetzung ins Englische / Translation CATHERINE SCHELBERT, BETTWIL
Scans GERT SCHWAB / STEIDL, SCHWAB SCANTECHNIK GBR, GÖTTINGEN
Gesamtherstellung / Production STEIDL, GÖTTINGEN

Barbara Davatz, «Portraits, 1982, 1988, 1997—As Time Goes By»
Edition Patrick Frey
c/o Scalo Zurich–Berlin–New York
Head Office: Weinbergstrasse 22a · CH-8001 Zurich / Switzerland
Tel. 41 1 261 09 10 · Fax 41 1 261 92 62
e-mail publishers@scalo.com · website www.scalo.com
Vertrieb / distributed in North America by D.A.P., New York City;
in Europe, Africa and Asia by Thames and Hudson, London;
in Germany, Austria and Switzerland by Scalo.

First Edition Patrick Frey Edition 1999
ISBN 3-905509-25-3
Printed in Germany